IMAGES
of America

ASHTABULA

PEOPLE AND PLACES

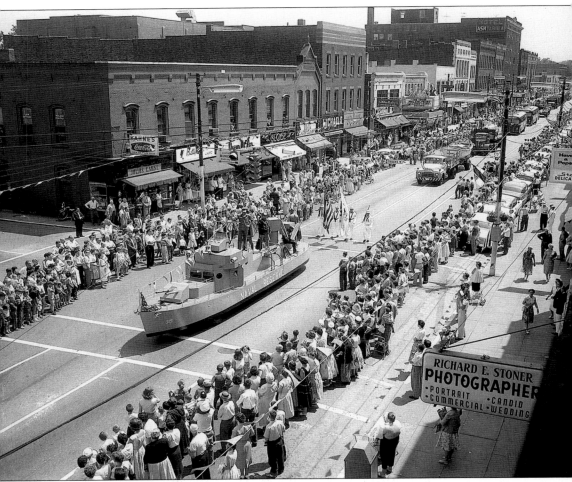

A MAIN AVENUE PARADE, C. 1957. Richard Stoner captured this parade from the window of his studio above Marshall's Drugs. There was a time in America when participating in or watching a parade was one of the major forms of entertainment available on holidays. (Richard Stoner photograph.)

Dedicated to the people of Ashtabula County.
They treasure their past.

IMAGES
of America

ASHTABULA

PEOPLE AND PLACES

Evelyn Schaeffer with
the photography of Richard E. Stoner

ARCADIA

Published by Arcadia Publishing
Charleston SC, Chicago IL, Portsmouth NH, San Francisco CA

Printed in Great Britain

Library of Congress Catalog Card Number: 2005928572

For all general information, contact Arcadia Publishing:
Telephone 843-853-2070
Fax 843-853-0044
E-mail sales@arcadiapublishing.com
For customer service and orders:
Toll-Free 1-888-313-2665

Visit us on the Internet at http://www.arcadiapublishing.com

On the cover: Shea's Theatre, on Main Avenue in Ashtabula, screened *Pagan Love Song* when the film was released in 1950. (Richard Stoner photograph.)

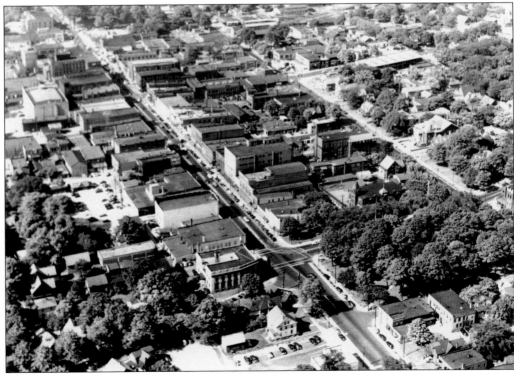

MAIN AVENUE, C. 1950. The irregularly shaped post office (lower center) dominates Main Avenue at the West 44th Street intersection. The large square building behind Main Avenue (upper left) is the newly constructed auditorium of Shea's Theatre. (Richard Stoner photograph.)

CONTENTS

ACKNOWLEDGMENTS

This book has been immeasurably enriched by the contributions of Walt Barnes, Sam Bucci, George and Barbara Ducro, J. Peter and Sue Ducro, Dick and Linda Dunbar, Dick and Grace Flower, Gene Gephart, Isabel Giangola, Bud Hill, Toni Imbrogno, Dick and Nancy Johnson, Alex and Margaret Lambros, Tom Lambros, John and Vivian Maille, Shirley Massucci, Benny McCluskey, Andy and Betsy McElroy, Esther Anderson Northrup, Mike Penna, Ralph and Candy Paulchel, Carmen Presciano, Fred Rounds, Dick Rowley, Gordon and Bonnie Van Allen, Joe Vendel, Dominic Volpone, the Frick Art and Historical Center, the *Ashtabula Star Beacon*, and the Great Lakes Marine and Coast Guard Memorial Museum.

I owe special thanks to Joe DelPriore and Ren Carlisle, without whom chapters 2 and 3 would not have been possible.

Florence A. Stoner, wife of the late Richard E. Stoner, provided the photographs that form the nucleus of this book. She also provided constant encouragement and support. Thanks, Flo.

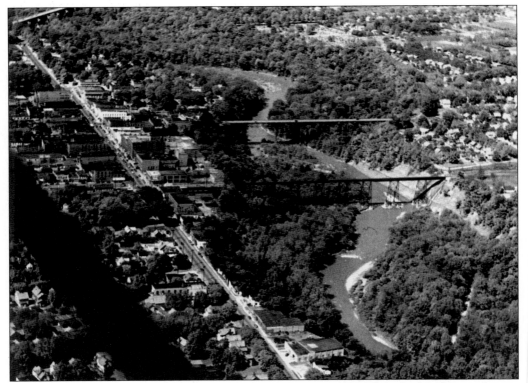

UPTOWN AND THE GULF, 1940s. Longtime residents remember when the Viaduct at the top left (north) of this photograph, built in 1928, was the "new" bridge, and Spring Street Bridge, built in 1895, was the "old high level" bridge. Spring Street became West 46th Street in 1930, but the old name is still in use. The railroad bridge was originally built by the Nickel Plate Railroad. (Richard Stoner photograph.)

INTRODUCTION

The history of Ashtabula, Ohio, is the story of a port and a village, the harbor and uptown. The city we know today actually developed from two distinctly different settlements that have been more divided than united by the "river of many fishes" that flows through them.

The Ashtabula River's outlet into Lake Erie was blocked by a large sandbar when George Beckwith settled on the "flats" in 1803. In 1819, the harbor on the east side of the river became the northern terminus of the Ashtabula–Trumbull County Turnpike, which stayed on the east side of the river until it crossed the gulf by a bridge in the river flats below Harmon Hill and climbed up Tannery Hill on the west side. Private efforts kept the sandbar clear. It was not until 1826, with the beginning of the canal era, that the government began making improvements in the harbor; the original river mouth was dammed up, a new channel was dug, and piers were constructed. The harbor's shipping activity remained on the east side of the river, and the docks were located upstream in what later became known as the inner harbor. A pontoon bridge was constructed across the river at what is now Fifth (Bridge) Street in 1850, for the first time allowing direct access to the west side at the harbor, where Matthew Hubbard had first settled in 1804. It was not until the railroads finally reached all the way to the harbor in 1873 that the outer harbor as we know it today began to develop and a business district and shipping activity began to grow on the west side of the river.

Uptown, about three miles from the harbor, the first settlers established farms and mercantile establishments on opposite sides of the large gulf created by the Ashtabula River. A bridge between Harmon and Tannery Hills allowed travelers to cross the gulf between the east village and the west village. Another bridge was located farther south along the Erie to Cleveland mail route road, which followed East 51st down into the gulf, then made the long climb up the west side along Spring Street, which joined Main Street at the location of West 46th Street. The pontoon bridges at the harbor and the early uptown bridges across the gulf were often impassable in bad weather. It was not until 1889 that the swing bridge replaced the pontoons at the harbor, and not until 1895 that the first high-level bridge was built uptown at Spring Street. The old river valley crossing at Tannery Hill remains, and a high-level viaduct, which realigned Route 20, was constructed in 1928.

The village of Ashtabula and the harbor joined together in 1877, but there was little practical connection between them until the trolleys became well established in the early 20th century. Even then, it was a true commuter situation to live uptown and work in the harbor. It was the physical distance between the two communities that led to the establishment of the Harbor Special School District c. 1885. The November 1902 Industrial Edition of the Ashtabula Beacon-Record explains that the community formed the district "to give her youth the best educational advantages."

The distance between uptown and the harbor also allowed for the development of distinct ethnic communities. The railroad, which reached uptown in 1852, drew Irish immigrant workers to the area; other immigrant groups, such as Germans and Greeks, developed communities in the business district. Swedes, Finns, and, later, Italians, worked and lived in the harbor. The city of Ashtabula incorporated in 1892, but the Harbor Special School District persisted for another century, as did some of the ethnic divisions within this small city.

This book concentrates on Ashtabula in the post–World War II period, a time when the great railroad era was drawing to a close at the harbor, while the manufacturing plants, particularly those to the immediate east, were expanding. Uptown's business district was still thriving. A majority of the photographs featured here were taken by local photographer Richard E. Stoner during this period.

The harbor is now dominated by the once small private dock company that was just beginning in 1952. All of the railroad infrastructure that defined the harbor's skyline for half a century is gone. Uptown retains many of the business blocks that were built between the Civil War and the Great Depression, when local entrepreneurs put their own names on large buildings that could house several businesses as well as halls and ballrooms for public use. But the business district has definitely shrunk; a number of the massive blocks and arcades have been replaced by the smaller one-story business buildings of the 1970s urban renewal era or by vacant lots.

The mid-20th century was also a time when America had essentially no competition in the world marketplace; the economies of postwar Europe and Japan were in shambles. The inexorable march of technology has taken Ashtabula to a future very different than citizens imagined when they were celebrating the sesquicentennial with a "Parade of Progress" in 1953. Private automobiles have replaced mass transit, personal entertainment systems have replaced community theaters and events, and multinational conglomerates have replaced the locally owned stores, restaurants, and factories that once drove our economy and participated in our community life. The 2002 census found that Ashtabula has a population of 20,482, a decrease of at least 20 percent since the 1950s.

Our history is in many ways unique to this particular spot on the south shore of Lake Erie, and in many ways it is also the history of many other small American cities. It is worth remembering and preserving.

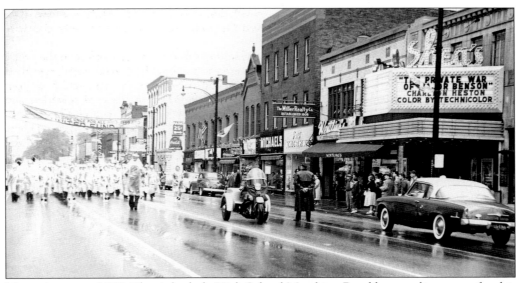

MAIN AVENUE, 1955. The Ashtabula High School Marching Band has a police escort for this event. Community parades were a far more frequent occurrence before electronic entertainment became commonplace. (Superior Camera Shop photograph, courtesy Frederick S. Rounds.)

One

MAIN STREET TO MAIN AVENUE

WHAT WAS IT LIKE UPTOWN?

What was it really like in the days that the postwar generation remembers from childhood, the days when Ike was president and words like "progress" conjured up nothing but images of a bright future? Was Ashtabula really the big, bustling, prosperous city we remember, or did it just seem big because we were small and seem prosperous because we were children? We all know that the lens of nostalgia can be unreliable. But the lens of a camera, particularly a camera wielded by a professional photographer with an eye for both detail and context, can provide a truer picture of our past. This chapter is organized around Richard Stoner's photographs of Ashtabula's main business district. The photographs were taken in the 1950s, when Stoner himself was a Main Avenue businessman.

Main Street became Main Avenue in 1930, and its cross streets, which until then had been named, were given numbers instead. Only Center Street officially retains its name, although West 46th Street is still commonly referred to as Spring Street. This chapter begins on the west side of Main Avenue at Stoner's studio, located at 4539 Main Avenue "over Marshall's Drug Store," as he noted in his professional advertising. From there, the photographs take us south along Main Avenue across Center Street and the railroad tracks to the old Church Street and South Park. Then we return to Stoner's studio and proceed north to the heart of the old village settlement, Division Street (West 44th Street), next to North Park. At the intersection of Main Avenue and West 44th Street, the photographs begin to capture the east side of the street, moving south past West 46th Street (Spring Street) almost to the tracks. Along the way, older photographs help to fill in the story of uptown and the people who shaped it and who continue to invest their lives in it.

It is important to remember that the landmark buildings that we mourn as lost to the urban renewal movement of the 1960s and 1970s were often replacements of landmarks built by previous generations. There were several distinct periods of rapid national expansion, which uptown Ashtabula's streetscape reflects. The original frame buildings put up by the earliest settlers and merchants on Main Street replaced log structures, and they were almost completely replaced with multistory brick blocks and arcades in the post–Civil War building boom. Many of these were ravaged by fire and were rebuilt or replaced by the more modern buildings of the 1890s and early 20th century. Main Street expanded and modernized in the Roaring Twenties and the post–World War II era, and more structures were replaced. But the last generation's changes seem more obvious because, for the first time, the changes in the business climate were not driven by the local businesses that anchored America's main streets. Now we see vacant lots where many of the old blocks were and newer buildings without the upper floors that characterized the blocks and arcades that housed small shops and offices in the early 20th century.

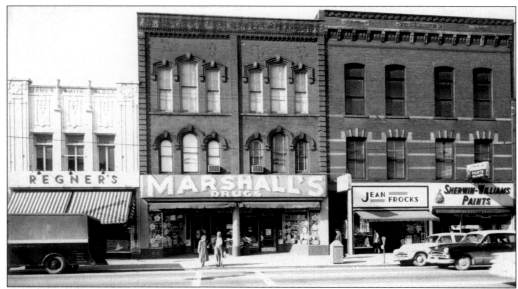

THE WEST SIDE OF MAIN AVENUE ACROSS FROM WEST 46TH STREET, C. 1957. Marshall's Drugs occupies the entire ground floor in this image, but the Willard Block was built in 1874 as two storefronts. George Willard, druggist, occupied the right side, and Carlisle and Tyler dry goods had the left. Here, photographer Richard E. Stoner occupies the second floor, where Carlisle's carpets used to be. The Collins Block was built around the same era, but the James Smith Block to the left shows distinct 1920s Art Deco design features. (Richard Stoner photograph.)

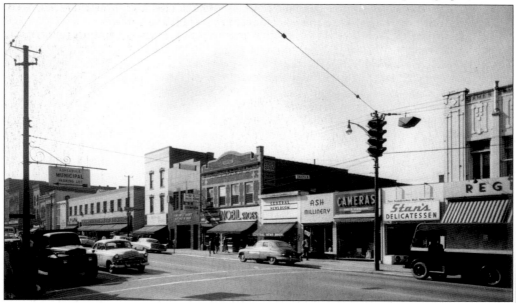

AN EVOLVING STREETSCAPE. The Chacona Block, home to Nobil Shoes, was built in the 1920s. The four one-story buildings to the right are old buildings whose upper floors burned and were not replaced. To the left is the *c.* 1950 red marble façade of the Ashtabula County Savings and Loan. The long, low Neisner building replaced the Smith Opera House, which burned in 1946. (Richard Stoner photograph.)

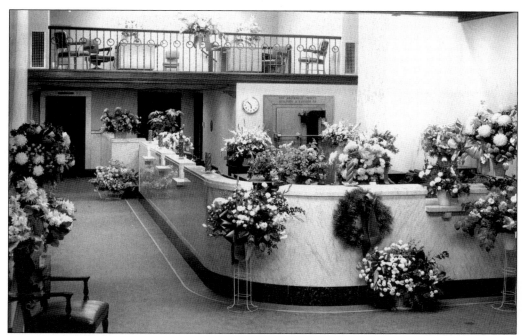

THE GRAND REOPENING OF THE BANK. The Ashtabula County Building and Savings was founded in 1901. It became the Ashtabula County Savings and Loan, and the old building was refaced in red marble *c.* 1950. A grand opening celebration was held when the renovations were complete. The balcony at the rear was common to bank buildings; from there, the bank examiners could observe the tellers at work. (Richard Stoner photograph.)

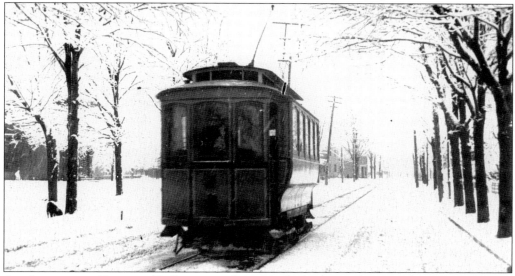

AN ASHTABULA TROLLEY. Trolley service between the harbor and uptown began in 1892, and by 1915, many businesses that had maintained stores in both places had closed their harbor branches. The trolleys were taken over by the city in 1922, but they soon faced competition from bus services. Trolley service ended for good in 1938. (Vinton N. Herron photograph, courtesy Florence Stoner.)

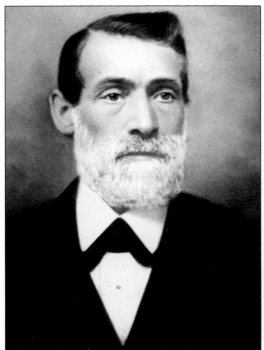

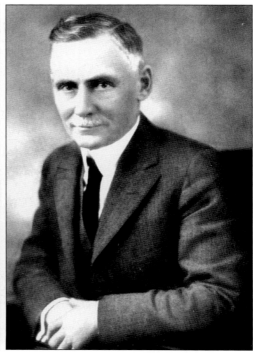

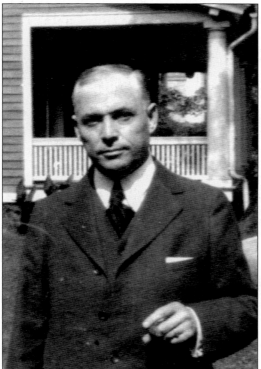

JOHN DUCRO, 1824–1904, AND HIS SONS. German immigrant John Ducro (above left) was both a cabinetmaker and an undertaker. By 1880, he had established John Ducro and Sons with a store on Main and one in the harbor. In 1892, the brick Ducro Block was built on the corner of Main and Center Streets. George Ducro (left) and John P. Ducro (above) operated the furniture and funeral business until 1940. (Above left and right, courtesy J. Peter Ducro; left, courtesy George Ducro.)

John Ducro's Sons Co., Inc.

OVER 68 YEARS OF SERVICE
RESULT IN THREE GENERATIONS
OF SATISFIED CUSTOMERS

Quailty Furniture

Artistic Rugs

**AMBULANCE
SERVICE**

**John
Ducro's
Sons Co., Inc.**

**FUNERAL
DIRECTORS**

THE ASHTABULA CITY DIRECTORY, 1929. Ambulance services were originally provided by funeral directors. The Ducros promoted their businesses, and their long history in the city, in this Yellow Pages advertisement. (Courtesy Michael Penna.)

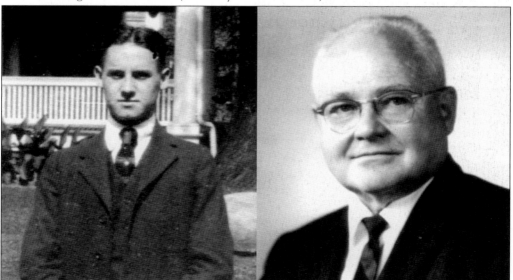

GEORGE E. DUCRO JR. IN 1919 AND JOHN TRUMAN DUCRO, 1901–1981. The corporation of John Ducro and Sons was dissolved in 1940, with the furniture business going to George Ducro Jr. and the funeral business to John T. Ducro. George E. Ducro III continued the furniture business until he sold to St. Angelo Furniture and retired in 1974. Ducro Funeral Services is still in operation. (Left courtesy George Ducro; right courtesy J. Peter Ducro.)

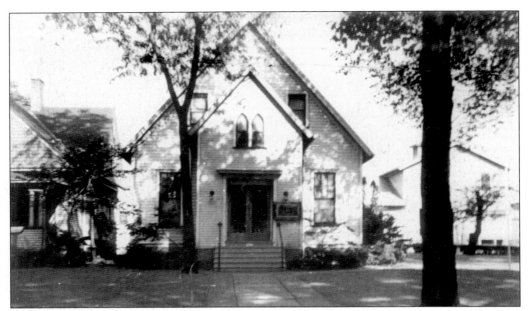

THE DUCRO FUNERAL HOME ON ELM STREET, C. 1950. This building, once used as the First Presbyterian Church's education building, was moved from the corner of Park Street (Park Avenue) and Vine Street (West 43rd Street) to this location in the early 20th century. It remains a part of Ducro Funeral Services and Crematory. In 1956, the building was moved back and incorporated into the remodeling of the large barn visible behind it. (Courtesy J. Peter Ducro.)

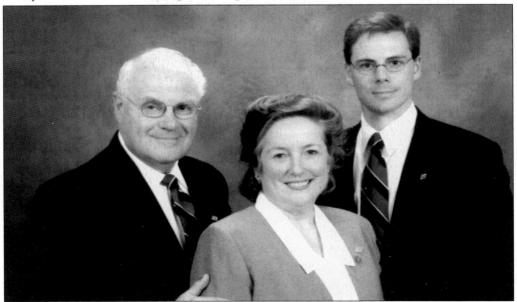

FIVE GENERATIONS OF SERVICE. Pictured in 1999 are, from left to right, J. Peter Ducro, Sue Curtis Ducro, and J. P. Ducro IV. Ducro Services is now Ashtabula's oldest continuously owned and operated family business, and it once again has locations uptown and in the harbor. The *Ashtabula Telegraph* observed in its 1882 sketch of John Ducro, "There is no branch of business more essential to the living than that which takes care of the dead." (Courtesy J. Peter Ducro.)

MAIN AND CENTER STREETS, C. 1911. The massive Ducro Block is at the left (south) in this image, with the Newberry Drug building occupying the other corner. All of these buildings fell to urban renewal. The Newberry Drug building was replaced by a parking lot, and the entire block from the south side of Center Street to the tracks became city property. Ducro Furniture built a new store on Park Avenue. (Postcard courtesy George Ducro.)

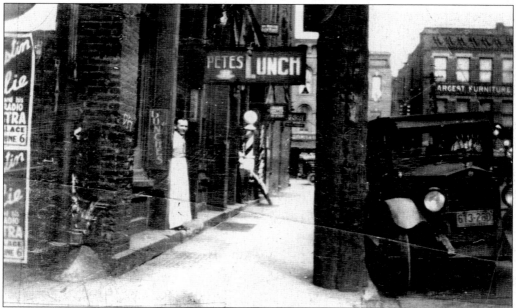

CENTER STREET LOOKING TOWARD MAIN STREET, 1927. Greek immigrant Peter Bellios stands in the doorway of his popular Pete's Lunch. His sister Mary married another Greek, Demetrios Peterson Lambros, who operated Central Billiards just two doors down. In 1938, the restaurant was moved into Central Billiards, where it continued in operation until the establishment was sold 10 years later. (Courtesy Alex Lambros.)

15

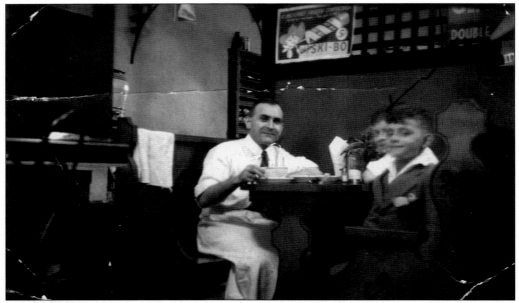

UNCLE PETE AND NEPHEWS, C. 1940. Mary Bellios Lambros and her husband had five sons, all with the middle name Demetrios according to Greek custom. Three remained in Ashtabula. Shown with Pete Bellios (left) at Pete's Lunch are Alex (rear) and the youngest, Tom. The billiards room was in the back, where a ticker tape reported the results of boxing matches and other events. Two hot dogs, pie, and coffee started at 25¢. (Courtesy Alex Lambros.)

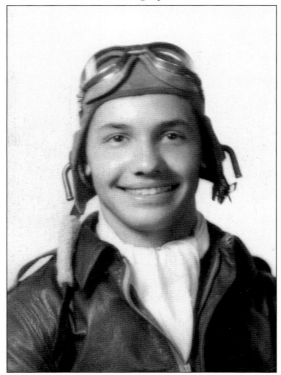

PETER D. LAMBROS. The eldest Lambros son, Peter, graduated from Ashtabula High School in 1941. He was killed in action on his 30th mission as a tail gunner over Linz, Austria, in 1945, and in 1949 the family established the Peter D. Lambros Memorial Award at Ashtabula High School. It is still given to the student chosen by the Lakeside High School faculty for outstanding journalistic achievement. (Courtesy Alex Lambros.)

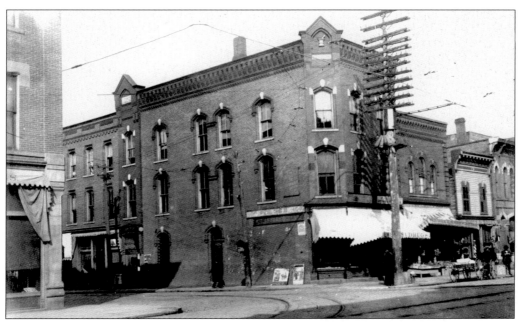

MAIN AND CENTER STREETS, C. 1890. This view clearly shows the mortar and pestle at the top of the Newberry Drug building. The second floor later housed the Ashtabula Business College, and the third floor had a large ballroom. Within a few years, the frame building to the right was replaced by the new Farmers Bank, as visible in the photograph below. (Courtesy Florence Stoner.)

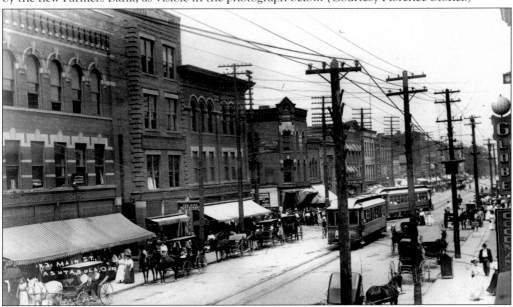

MAIN STREET, C. 1902. At the left is the Fair Store, the department store run by D. L. Davis in the block that bore his name. The narrow building next to it is the Warren Hotel. The Ducro Block on the corner of Center Street survived the 1966 fire that destroyed the buildings to the south, but it fell to the wrecking ball in the 1970s. At the far right, the Globe Clothiers sign on the Morrison Block is visible. (Courtesy George Ducro.)

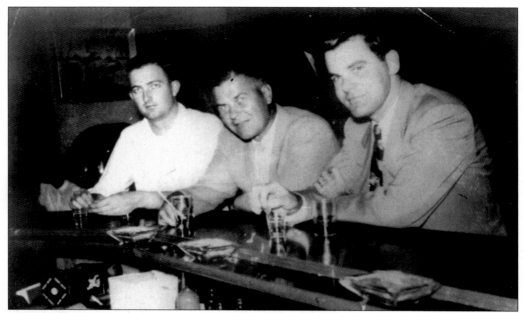

THE FLAMINGO LOUNGE, 1950. Pictured are, from left to right, Dick Reinker, an engineer for Ashtabula Bow Socket; Jack Toikkanen of the Carlisle-Allen Company; and Dick Johnson of the Carlisle-Allen Company. The Warren Hotel's bar was a popular Friday night watering spot. (Courtesy Richard Johnson.)

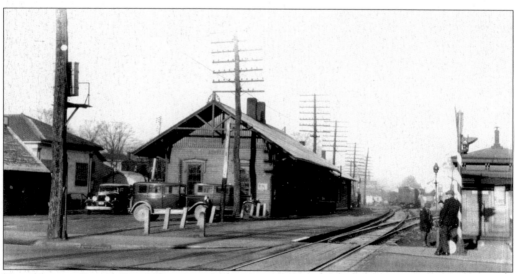

THE NICKEL PLATE RAILROAD DEPOT, C. 1925. The Nickel Plate Railroad came through Ashtabula in 1881. The train station was located on south Main Street. Rail passenger service and bus service brought people into the city for shopping and services until the 1950s, when Americans increasingly turned to private automobiles. This depot sat vacant for years before it was torn down in 1978 by Conrail. (Courtesy George Ducro.)

THE FIRST ST. PETER'S EPISCOPAL CHURCH BUILDING. This wood-frame building was completed on February 22, 1829, and faced what is now known as South Park. In 1962, it was replaced with a much larger brick building and annex. (Perry Burgess photograph, courtesy George Ducro.)

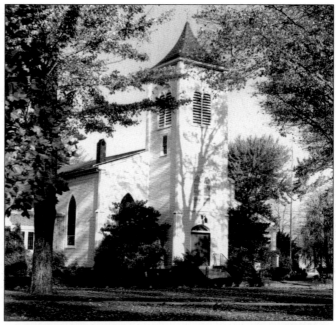

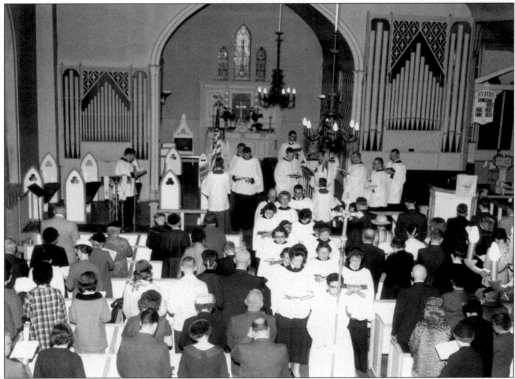

THE LAST SERVICE AT OLD ST. PETER'S, C. 1960. Because the new church was built on the same location, services were held in the parish house during the two years of construction. (Perry Burgess photograph, courtesy George Ducro.)

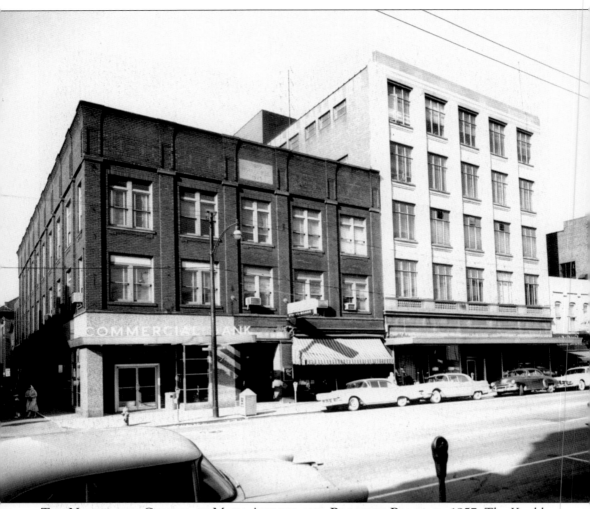

THE NORTHWEST CORNER OF MAIN AVENUE AND PROGRESS PLACE, C. 1957. The Kunkle Arcade on the corner was built with two floors in 1909 and expanded to three in 1925, when the new three-story Carlisle-Allen building went in. At the far right is the Masonic Temple, built in 1926. The small building in between, which predates both, was Chester H. Cooper clothing. Here Carlisle's is still contained in the Carlisle-Allen building, which had two stories added in 1941. Beginning in 1959, Carlisle's began to expand to neighboring buildings, eventually taking over the entire Kunkle Arcade. To the north, the F. W. Woolworth awning is just visible on the first floor of the Masonic building; the J. C. Penney store occupied this space until 1940. In 1962, Woolworth's moved to the new plaza on Lake Avenue, and Carlisle's leased the space for its children's department. The small building, by then occupied by East Ohio Gas, was torn down and replaced with a three-story addition to Carlisle's in 1969. Just visible at the left along Progress Place is the side of the old YMCA building, which was in use until a new combined Family Y was built on the corner of Prospect and Lake Avenues in 1960. Carlisle's acquired the old Y building and tore it down in 1965 to make more parking. (Richard Stoner photograph.)

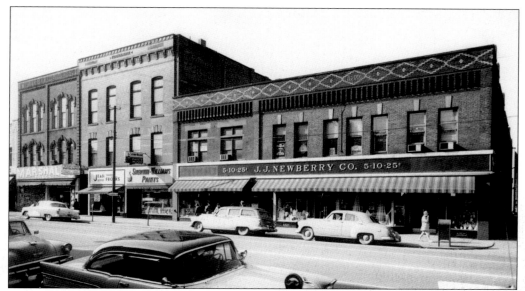

Southwest Corner of Main Avenue and Progress Place, c. 1957. The 1874 Willard Block, at the left, and its neighbor, the Collins Block, housed S. S. Kresge, the Great Atlantic and Pacific Tea Company (A&P), and the Ashtabula Sugar Bowl in the 1920s. The Wood Block was the location of the F. J. Wood and Company department store, which was bought out by L. T. Carlisle and Miles Allen in 1911. In 1925, Carlisle's moved to its new building, and Newberry's moved in. (Richard Stoner photograph.)

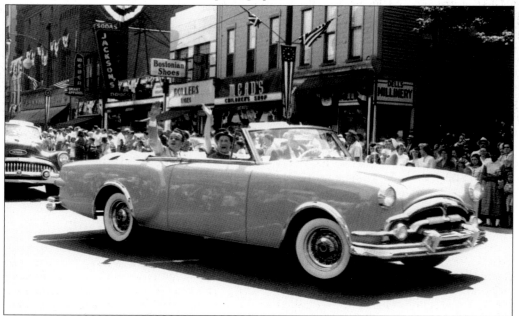

From Carlisle's to West 44th Street, 1953. During Sesquicentennial Week in 1953, 11th District congressman Oliver P. Bolton rides past a streetscape that remains today. Weber's Apparel and Rollers Shoes had been in these locations since the 1920s. The last two storefronts were later re-sided to make them look like one continuous building. (Richard Stoner photograph.)

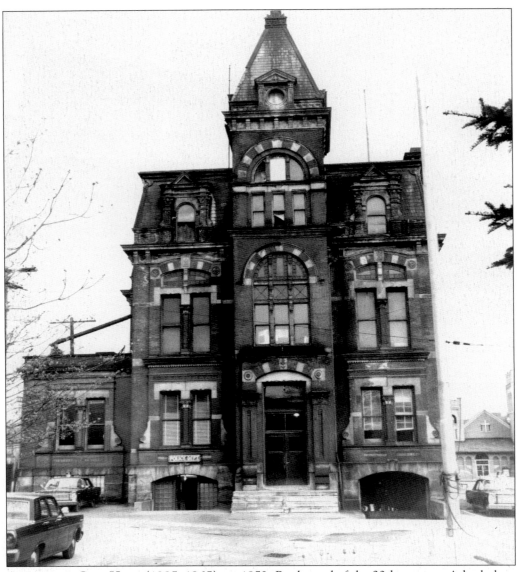

ASHTABULA CITY HALL (1885–1965), C. 1952. By the end of the 20th century, Ashtabulans had within their memory three generations of city halls. This building was bid in 1882 and completed in 1885 at a cost of $45,000. The November 1902 Industrial Edition of the Ashtabula *Beacon-Record* describes it as follows: "The first floor is given up to offices of city and township officials, council chamber and the police courtroom. The basement contains the Central Police Station jail and the storeroom and the workshop of the city electricians. A large hall and adjacent ante-rooms, dressing rooms, etc., occupy the entire second floor." In 1920, the ceiling was lowered in the large hall on the second floor, and the hall became offices. The Ashtabula Township offices were in this building until 1955, when they moved to East Prospect Street (Route 20); the city offices remained here for another 10 years. This building on Division Street (West 44th Street) originally fronted on Main Street, set back from the road by a large area known as City Hall Park. By the time of this photograph, Collins Court had been built between the park and city hall; it later disappeared into the Carlisle's parking lot. (Courtesy Alex Lambros.)

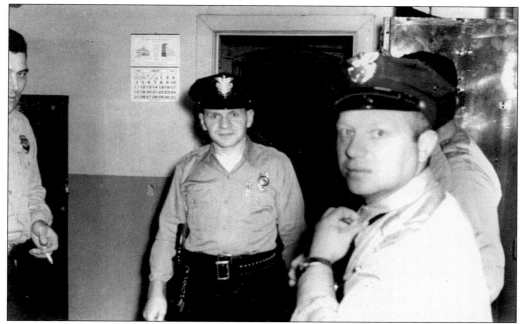

THE POLICE LOCKER ROOM, 1954. Third-shift patrolmen pictured here are, from left to right, William Oliver, Alex Lambros, and Harry "Brudy" Brudapest. The city did not have a detective bureau until 1966; patrolman Alex Lambros went on to become captain of the bureau in 1971. For years, Lambros also moonlighted as head of security for Carlisle's. (Courtesy Alex Lambros.)

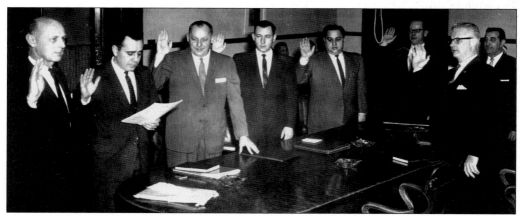

SWEARING IN THE CITY COUNCIL, 1962. Pictured are, from left to right, Cliff Kadan, president; Ronald Varckette, city solicitor; Joseph Stark, Ward 5 councilman; George Ducro, Ward 4 councilman; Edward Muto, Ward 3 councilman; William Brown, vice president; Duane Searle, Ward 1 councilman; and James Timonere, Ward 2 councilman. The ceremony took place in the first-floor courtroom, which also served as council chambers. (Courtesy George Ducro.)

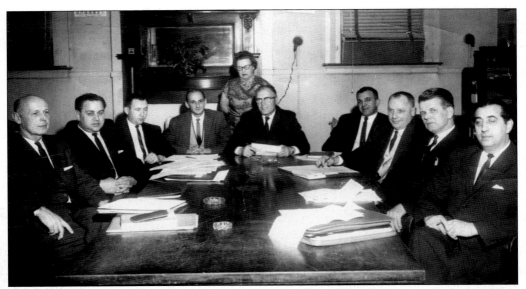

THE 1964 CITY COUNCIL. Pictured are, from left to right, Cliff Kadan, vice president; Edward Muto, Ward 3 councilman; George Ducro, Ward 4 councilman; James Warren, city solicitor; Nelma Rinto, clerk; Anthony Zalimeni, president; David DeLuca, city manager; Joseph Stark, Ward 5 councilman; John Jarvela, Ward 1 councilman; and James Timonere, Ward 2 councilman. The auditor's office shows the necessary multiple extension cords. This council was the last to use what would shortly become known as "old city hall." (Courtesy George Ducro.)

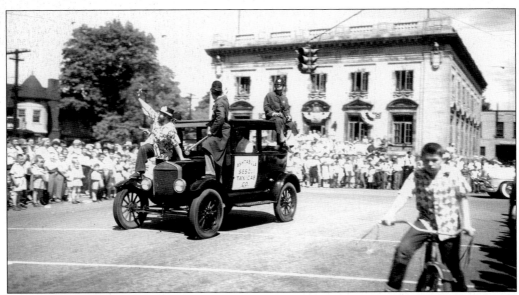

THE FEDERAL BUILDING AND POST OFFICE, 1953. This 1910 Beaux Arts–style building is one of over 25 nationwide that was designed by James Knox Taylor, the supervising architect of the U.S. Treasury. It is on the east side of Main Avenue; the crowd is standing in the street. The post office was relocated in 1962, and the city bought and refurbished this building for $350,000 in 1965. Old city hall across Main Avenue was then torn down, and the property was leased to Carlisle's for more parking. (Richard Stoner photograph.)

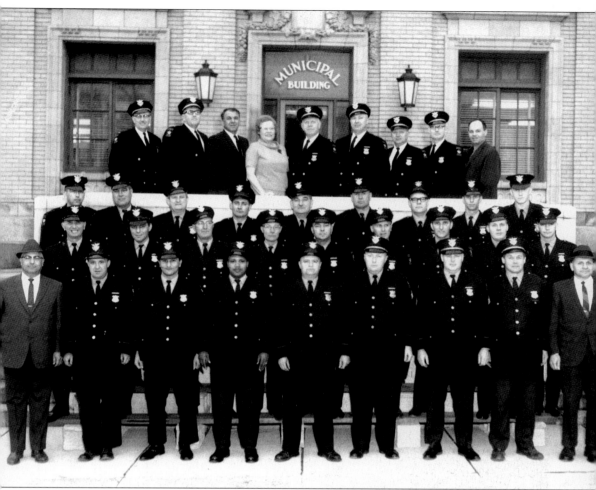

THE ASHTABULA CITY POLICE DEPARTMENT, 1967. Pictured are, from left to right, the following: (first row) Det. Lt. Ernest Savarise, Richard Bourdeau, Paul Eurez, Augustus Powell, Louis Kelner, Sgt. Perry Johnson, Sgt. Melvin Armstrong, Sgt. Alan Wuori, and Det. Alex Lambros; (second row) John Benedict, Joe Pete, William Stauffer, Clarence Holcomb, Paul LaRue, Francis Phelps, Joe Foglio, Thomas Broad, and Larry Brammer; (third row) John Meyer, William Oliver, Richard Balog, James Morehouse, Emery Roskovics, William Nurminen, Digby Kent, Don Rosetti, and Howard Stewart; (fourth row) Lt. Herb Andrews, Lt. Robert Diffenbacher, City Manager David DeLuca, Secretary to the Chief Mamie Kinunen, Chief Gordon E. Arvidson, Capt. Robert Luke, Lt. Harry Brudapest, Lt. James Clint, and Head of Maintenance Kaarlo Wuori. The first three rows of men are standing in front of a wall that is engraved with John F. Kennedy's famous words "Ask not what your country can do for you—ask what you can do for your country." This building became the second "old city hall" in the 1990s, when the city offices moved to the new Key Bank building on the corner of Main Avenue and Center Street, where the Ducro Block, the Warren Hotel, and D. L. Davis's Fair Store once stood. (Courtesy Alex Lambros.)

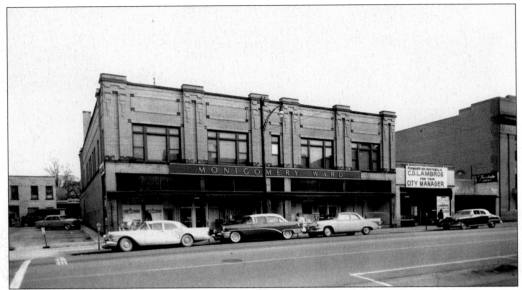

THE EAST SIDE OF MAIN AVENUE, C. 1957. Montgomery Ward was built in 1928. In 1957, Ashtabula changed its charter to make the city manager an elected position, and city solicitor C. D. "Gus" Lambros, the third son of Mary and Demetrios Lambros, became the first elected city manager. After being elected to a second term, Lambros resigned to take a governor's appointment, and David DeLuca was appointed to take his place. DeLuca served four terms, then lost the 1970 election to George Ducro. (Richard Stoner photograph.)

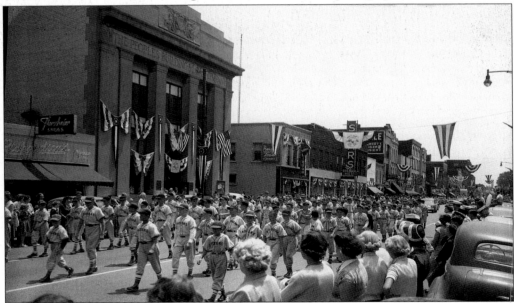

LOOKING SOUTH TO WEST 45TH STREET, 1953. Little Leaguers march past the imposing Peoples Building and Loan Company during Sesquicentennial Week. Peoples eventually expanded into the space occupied by Richardson's shoe store. After Peoples merged with First Merit and moved to a new building on Park Avenue in 1980, the Cleveland Electric Illuminating Company maintained offices here until 2003. (Richard Stoner photograph.)

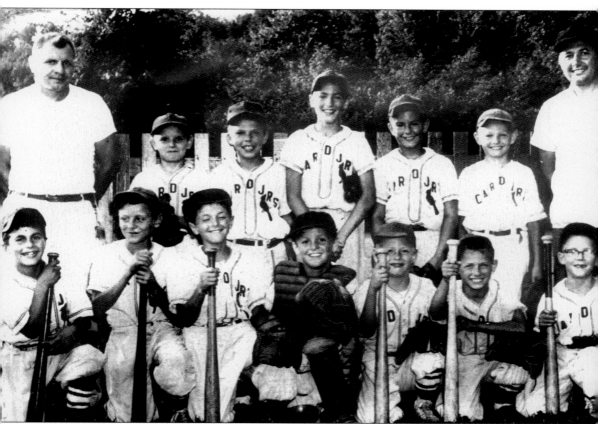

THE CARDINAL JUNIORS, ASHTABULA LITTLE LEAGUE MINOR-LEAGUE CHAMPIONS, 1959.
Pictured are, from left to right, the following: (front row) Thomas Simon, Louis DiDonato, Anthony Severino, Monte Foltz, David Jordan, James Krystanak, and Dennis King; (second row) manager Alex Lambros, David Clemens, Richard Korpi, Richard Altman, David Andrus, James Lambros, and coach Herb King. Thomas Simon became city solicitor on December 1, 1985. Anthony Severino still owns the Balkan Bakery. David Clemens became a city police officer. James Lambros studied medicine and returned home to practice in the 1990s. Little League Baseball of Ashtabula was formed in 1950 through the efforts of E. R. Cederquist, Dick Regner, Cliff Smith, Bill Martin, and Wayne Howsmon. Permission was secured to use the old Civilian Conservation Corps land in the gulf at the bottom of Harmon Hill, and the Rotary Club put in the field. Six teams played the first season, and by 1957, there were two six-team leagues. The Ashtabula Little League field was eventually renamed Cederquist Park in recognition of Ashtabula's first Little League commissioner. (Courtesy Alex Lambros.)

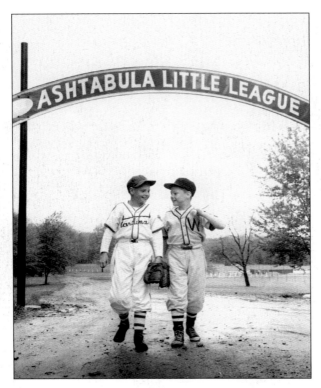

FROM THE *ASHTABULA STAR BEACON*, 1961. The caption with this photograph reads, "A pair of eager Little Leaguers, Jimmy Lambros of the National League in Cardinal uniform and Jimmy Carter representing the American League in Washington Senators uniform, discuss the season ahead as they pass under the new sign at the Little League Park entrance. Little League action gets underway this week." (Courtesy Alex Lambros.)

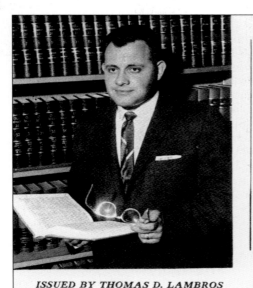

JOIN THE CRUSADE *for* JUSTICE

E L E C T

THOMAS D.

LAMBROS

J U D G E

Court of Common Pleas

Full Term Beginning Feb. 9, 1961
NON PARTISAN JUDICIAL BALLOT
"EQUAL JUSTICE FOR ALL"

2

ISSUED BY THOMAS D. LAMBROS *618 HOLDEN DRIVE* *ASHTABULA, OHIO*

THOMAS D. LAMBROS'S FIRST CAMPAIGN. The youngest of the Lambros boys was admitted to the bar at age 22 and practiced law with his older brother C. D., who was known as Gus. Thomas Lambros won this race and ran unopposed for a second term in 1966. (Courtesy Alex Lambros.)

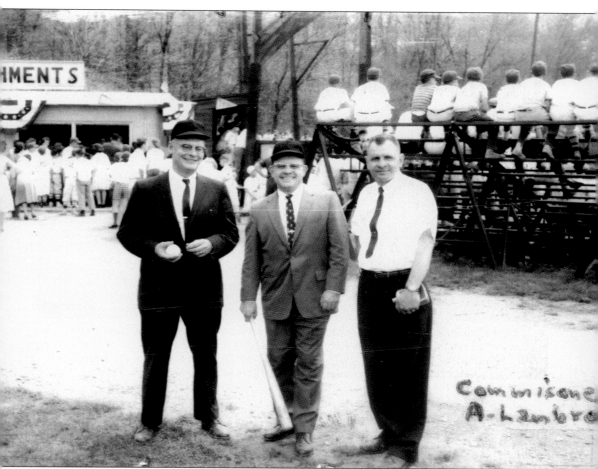

OPENING DAY. County prosecutor Robert Webb, left, joins common pleas judge Thomas Lambros and his brother Alex Lambros, Little League commissioner, at the newly refurbished Ashtabula Little League field. In 1967, Tom Lambros was appointed by Pres. Lyndon B. Johnson to the U.S. District Court in the Northern District of Ohio. At 37, he was the youngest man ever to hold a federal judgeship, and the first of Greek ancestry. His father placed the judicial robes upon his son's shoulders at the federal building in Cleveland. From 1990 to his retirement in 1995, Tom Lambros served as chief judge of that court. In 1996, Pres. William J. Clinton authorized the naming of the federal building in Youngstown after Lambros. Tom Lambros never moved from Ashtabula. In 2005, he lived in the same house he lived in when he ran for common pleas judge in 1960. As a judge, he pioneered the summary jury trial, and he continues to be active in the legal arena in conflict resolution. Of the five Lambros brothers, only one moved from Ashtabula; Christ Lambros became a teacher and coach in Erie, Pennsylvania. (Courtesy Alex Lambros.)

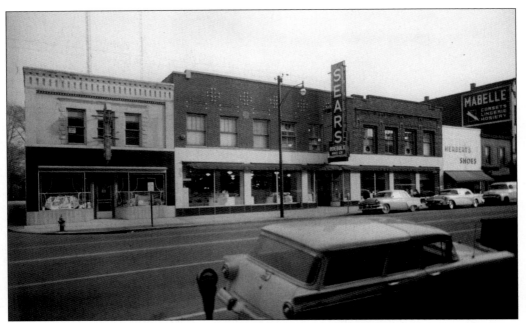

A VANISHED STREETSCAPE. The east side of Main Avenue was hit hard by urban renewal. The only buildings remaining in the entire block between West 45th and West 46th (Spring) Streets are the Sears building, seen here in 1957, and J. C. Penney, seen on the facing page. In the early 20th century, the Patrick Cahill Saloon stood on the corner next to the Cook Arcade, where DeRosa's Bar and Café is located in the photograph above. Sears, Roebuck and Company came to Ashtabula *c.* 1935 and took over the front part of the Cook Arcade. The Krizt Block, where Mabelle Reed's corset shop was located in the 1950s, was built *c.* 1915. The graceful A. H. Tyler building, erected in the 1870s, held one of many uptown public halls at a time when meetings of societies, clubs, and fraternal organizations provided much of the local entertainment. (Richard Stoner photographs.)

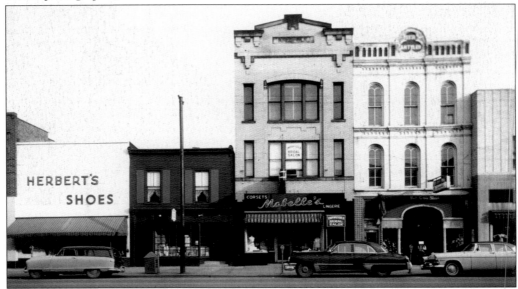

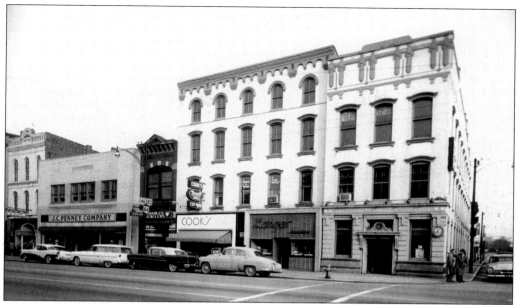

THE NORTHEAST CORNER OF MAIN AVENUE AND EAST 46TH (SPRING) STREET, C. 1957. The Lawton Building was remodeled in 1940 for the J. C. Penney Company. From the early 20th century until 1939, James Thorpe and Company showed "moving pictures" here, and by 1916, it was known as the Casto Theater. In 1918, the Casto was acquired by the Shea Theatre Company, which operated it until 1939. All of the other buildings were replaced with new construction during the 1970s. (Richard Stoner photograph.)

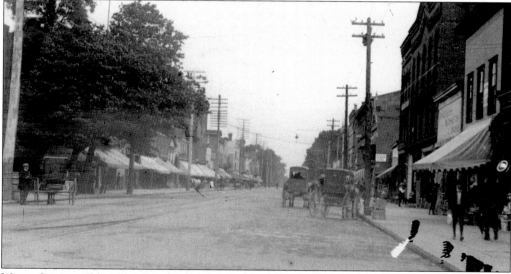

MAIN STREET, LOOKING NORTH FROM CENTER STREET, C. 1900. The 1882 year in review edition of the *Ashtabula Evening Record* noted that "paving Main Street [was] the absorbing question." The building halfway down the east side of the street with the small white placard on the side is the C. E. Ziele Saloon, which also showed moving pictures. It was right next to the Ashtabula House. Today it is a restaurant. The buildings at the right made way for the Shea Building in 1927. (Courtesy Florence Stoner.)

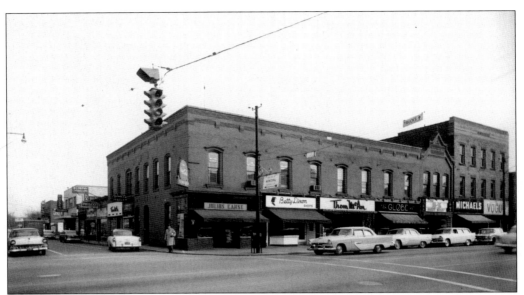

THE SOUTHEAST CORNER OF MAIN AVENUE AND EAST 46TH (SPRING) STREET, 1957. Visible here are the old Ashtabula House and the Ziele Saloon (the building with the peaked façade). The large block to the right was replaced in the 1970s. Sometime after this photograph was taken, the Globe storefront part of the Ashtabula House was re-sided with clapboards. At the end of East 46th Street is the Bula Theater, another of the Shea Theatre Company's theaters in Ashtabula. (Richard Stoner photograph.)

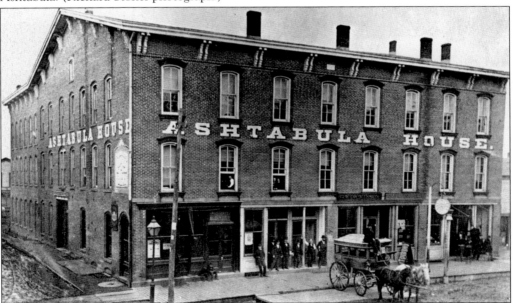

THE SOUTHEAST CORNER OF MAIN AVENUE AND EAST 46TH (SPRING) STREET, 1865. The imposing Ashtabula House hotel and tavern had three floors and four storefronts when it was built on Main Street, which had wooden sidewalks at the time. The top floor burned and was not replaced, but the first two floors and the storefronts have survived into the 21st century. (Courtesy Ren Carlisle.)

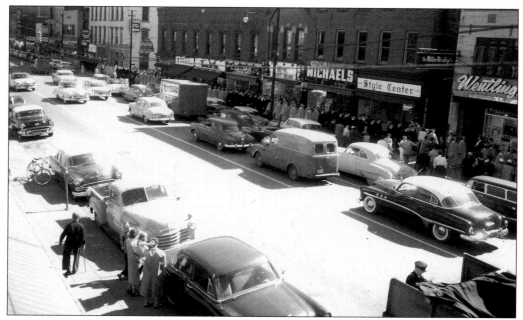

WALKING TO GRADUATION AT SHEA'S THEATRE, EARLY 1950S. Ashtabula High School first used the new Shea's in 1949. Principal E. I. Gephart arranged to use the facilities for free if the event did not interfere with shows. At the lower right corner of the photograph is iceman Mose Squires making a morning delivery. (Richard Stoner photograph.)

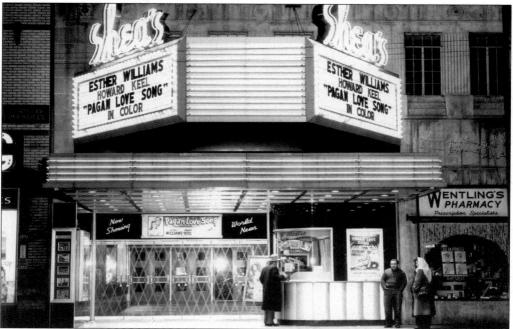

ASHTABULA'S GRANDEST THEATER, 1950. The storefront part of Shea's was built in 1927–1928 and was occupied by a variety of businesses and professional offices until the construction of the massive auditorium was begun following World War II. (Richard Stoner photograph.)

GRAND OPENING WEDNESDAY, FEBRUARY 2, 1949

SHEA'S
ASHTABULA

This Ticket for
10:30 o'clock
Performance
ONLY

Presenting
JUNE ALLYSON -- PERRY COMO
JUDY GARLAND -- LENA HORNE -- GENE KELLY
MICKEY ROONEY -- ANN SOTHERN

in

Metro-Goldwyn-Mayers
"WORDS AND MUSIC"
(TECHNICOLOR)

Bob Russell
MGR.

Theatre
OHIO

INC. CITY TAX50
FEDERAL TAX10
TOTAL60

N⁰ 259

**SHEA'S
THEATRE**
ASHTABULA, OHIO

Wed., Feb. 2nd
1949

INC. CITY TAX50
FEDERAL TAX10
TOTAL60

10:30 o'clock
Performance Only

N⁰ 259

A GRAND OPENING TICKET. Dominic Volpone remembers standing in line for the 10:30 p.m. show and seeing fire on the other side of Main Avenue. As the smoke billowed across the street, the theater blowers had to be shut off, and management tried to cancel the show. People refused to leave, and when the fire was finally under control, the show went on at midnight. (Courtesy Dominic Volpone.)

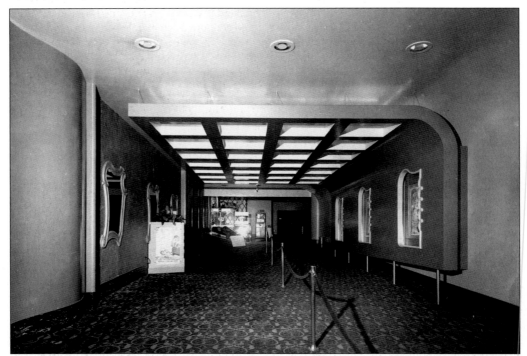

THE LOBBY. The 100-foot-long lobby dates from the 1927 construction of the Shea Building. It was completely remodeled in 1948, when the auditorium was built. Pink Georgia marble was used extensively in the theater's Art Moderne architecture, complemented by deep rose, blue, and gray in the carpet and theater curtains. The carpet was a design specially woven for the Shea Theatre Company and used only in the Ashtabula and Erie theaters. (Superior Camera Shop photograph, courtesy Frederick S. Rounds.)

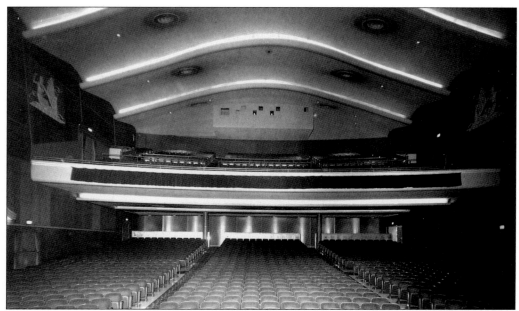

A MULTIPURPOSE ENTERTAINMENT HOUSE. Shea's had 930 seats on the main floor and 600 in the balcony. The stage, measuring 78 by 30 feet, could accommodate vaudeville acts, road shows, and concerts as well as films; the movie screen could be raised straight up into the overhead. Six vertical lighting coves on each side of the stage masked colored lights on dimmers, and the flameproof curtains surrounding the plush rose-colored silk act curtain were made of gray and turquoise damask. Shea's was truly a focal point of the community, bringing top acts such as Liberace and Lawrence Welk to town in addition to the steady stream of first-run movies, and it made its facilities available for events such as Ashtabula High School graduation. (Superior Camera Shop photographs, courtesy Frederick S. Rounds.)

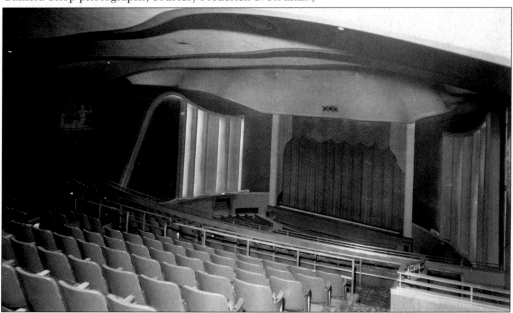

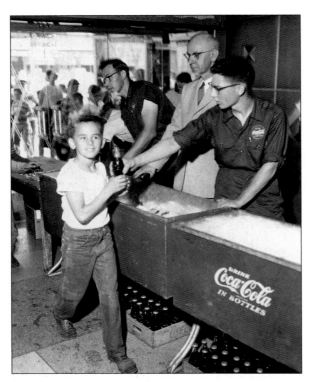

THE COCA-COLA SHOWS. One Saturday morning a month during the summer, Fred Knuebel of the local Painesville Coca-Cola Bottling Company (seen here in the suit) sponsored a promotion at Shea's. Ten bottle caps bought a coke, a bag of popcorn, and admission to the show, which consisted of cartoons, a couple of *Three Stooges* shorts, and a main feature. (Superior Camera Shop photograph, courtesy Frederick S. Rounds.)

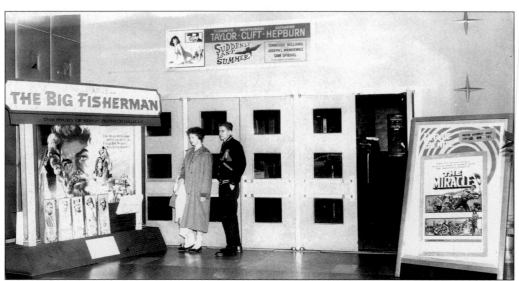

THE OUTER LOBBY, 1959. A generation of Ashtabula's young people, including this unidentified couple, spent their dating years at Shea's. Frederick S. Rounds started working as an usher while he was still in high school and eventually became a manager for the company. Rounds notes, "My wife and I first met in the lobby of the Shea's Theatre." (Superior Camera Shop photograph, courtesy Frederick S. Rounds.)

THE ASHTABULA HIGH SCHOOL CHEERLEADING SQUAD, 1950.
Pictured here are, from left to right, the following: (first row) Marguerite "Mugsy" Skullman, Evelyn Baker, and Jane Church; (second row) Esther Anderson, Shirley Soderman, and Shirley Watson. Lavilla Phares called them her "jumperettes." (Courtesy Esther Anderson Northrup.)

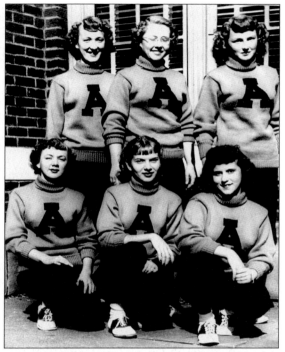

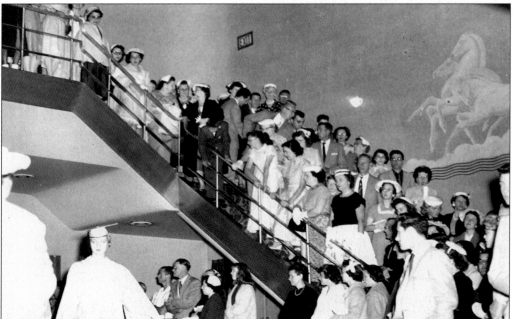

CONGRATULATING THE GRADUATES. The cheerleaders above had their turn to greet family and friends in the grand foyer of Shea's after the commencement ceremonies. The harbor still had its own high school, a legacy of the Harbor Special School District set up by special legislation c. 1885. The rivalry between "Harbor" and "Bula" was fierce right up until a successful consolidation in the 21st century. (Superior Camera Shop photograph, courtesy Frederick S. Rounds.)

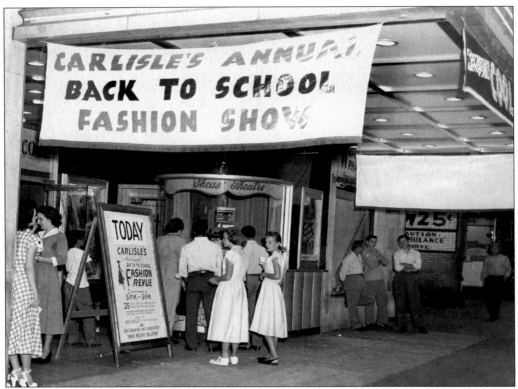

ANOTHER EVENT AT SHEA'S, 1950S. In the days before television brought fashion trends into homes on a daily basis, the theater could accommodate many more fashion-conscious patrons than in-store fashion shows could. Downtown Ashtabula's major department store, Carlisle-Allen, often had window displays that tied in with major films shown at Shea's. (Courtesy Ren Carlisle.)

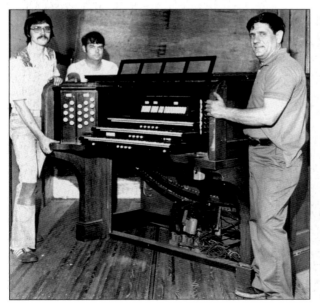

RESTORATION WORK, 1977. Richard Roberts, William "Bud" Hill, and Dominic Volpone, pictured here from left to right, move the console for a 1,500-pipe organ into the theater. In 1973, the grand theater suddenly closed. Times had changed, and Shea's had competition from the new multiplex cinemas in the strip plazas as well as from television. The community, led by the Ashtabula Branch of the American Association of University Women, worked to "Save the Shea," and in 1976 Burke Shea donated the facility to a nonprofit community association. But by 1982, the theater was shuttered again. (Courtesy *Ashtabula Star Beacon*.)

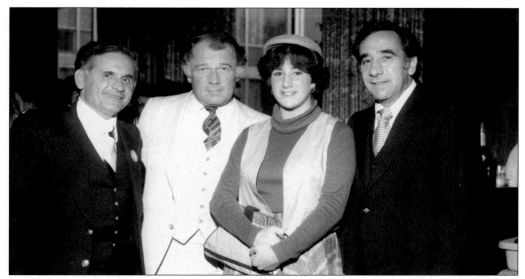

F. LEE BAILEY COMES TO TOWN, 1978. Pictured above are, from left to right, C. D. Lambros, F. Lee Bailey, Tammy Varckette, and local attorney Frank Varckette. C. D. "Gus" Lambros was running for common pleas judge, and he staged a campaign event at the nonprofit Shea's Theatre. The advertisements read, "Two noted trial lawyers . . . now meet again for an educational and informative evening." After the program, the men retired to the Hotel Ashtabula's Tavern Restaurant, where Richard Stoner photographed the participants. Stoner is seen in the middle of the photograph below. Lambros narrowly lost this race to Joseph Malone. Shea's Theatre remains in downtown Ashtabula. The storefront and long lobby are now occupied by the Ashtabula Senior Center. As Ashtabula struggles to reinvent itself for the 21st century, there is another movement afoot to restore Shea's as a community venue. (Richard Stoner photographs.)

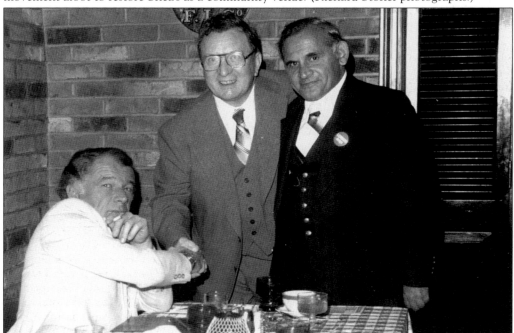

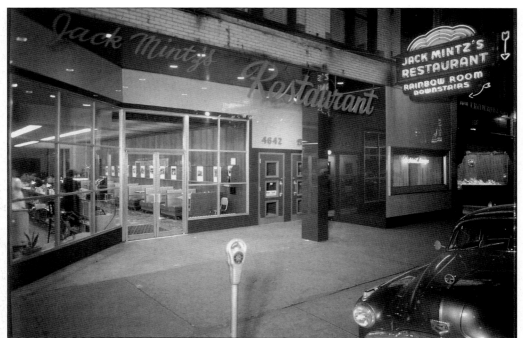

JACK MINTZ'S RESTAURANT AND RAINBOW ROOM, EARLY 1950S. Washington Lunch occupied this location until Jack Mintz bought out owners Mike, Louis, and Jim Christos in 1947. The restaurant and nightclub operated until 1953, when a fire in the kitchen closed it down. Locals still remember that rising star Johnny Ray sang in the Rainbow Room nightclub downstairs. The story is that Jack Mintz fired him. (Richard Stoner photograph.)

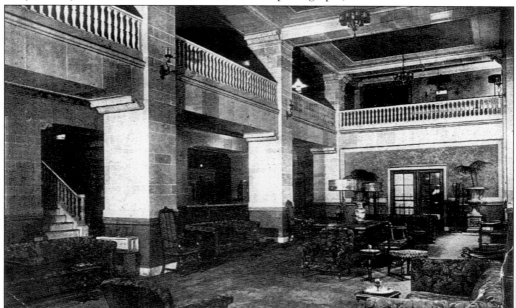

THE LOBBY OF THE HOTEL ASHTABULA. The ballroom was located on the mezzanine level. (Postcard courtesy George Ducro.)

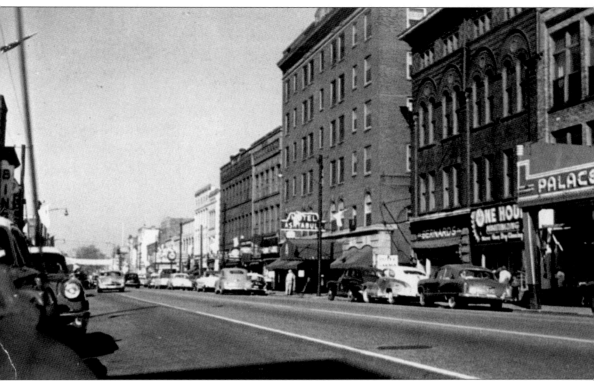

THE HOTEL ASHTABULA ANCHORS SOUTH MAIN AVENUE, C. 1953. This Renaissance Revival–style hotel was built in 1920. It included a ballroom seating 300, a dining room for 125, a lounge and restaurant, and rental social rooms. It was advertised as fireproof, a claim that was put to the test twice. Not long after the hotel was built, fire destroyed the Lattimore Block and the Palace Theater. Then, in February 1965, a daytime fire in the Satellite Bar and Grill in the Nettleton Block to the north of the hotel burned for over 24 hours, destroying that block and the Morrison Block, the location of Penny's Furniture. The fireproof hotel survived and there was no loss of life, but hotel occupancy ceased. For at least 20 years more, the hotel remained open as a restaurant and for social functions. The massive blocks at each side of the Hotel Ashtabula were never rebuilt. The urban renewal movement of the 1960s and 1970s rerouted traffic and made a pedestrian-only business district called Arrowhead Mall. These "downtown malls" were unsuccessful in most cities, and after 30 years Main Avenue was again opened to traffic. The hotel building, listed on the National Register of Historic Places, has survived and may someday host other businesses. (Postcard courtesy George Ducro.)

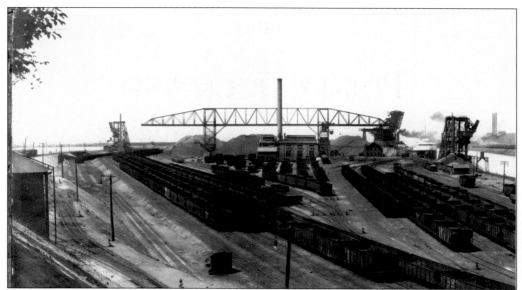

THE PENNSYLVANIA RAILROAD DOCKS IN THE FIRST HALF OF THE 20TH CENTURY. The Pennsylvania Railroad (Pennsy) docks were on the west side of the Ashtabula River. This view, looking north, shows Dock 11 at the far end and Dock 10 nearest the ore bridge. Dock 6, established in 1916, is seen farther upriver. The stack on the powerhouse in the center of the photograph was taken down in 1941. These docks closed in 1966, when the Pennsylvania and New York Central Railroads merged. (Richard Stoner photograph.)

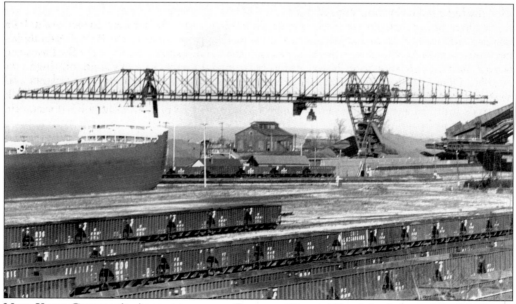

NEW YORK CENTRAL'S ASHTABULA AND BUFFALO DOCK. The Ashtabula and Buffalo Dock, known as the A&B Dock, was located immediately east of the river. Part of a rank of Huletts is visible on the right (east) side of the photograph. Electric Huletts were installed in Ashtabula Harbor in 1910. The breakdown of one Hulett in 1972 at New York Central's Union Dock was the beginning of the end; the dock closed in 1978. (Richard Stoner photograph, courtesy Pinney Dock.)

Two

PINNEY DOCK AND
TRANSPORT COMPANY

ASHTABULA'S SEAWAY PORT OF PROGRESS

Ashtabula was a railroad town. For over 100 years, it seemed that everyone either worked for one of the railroads or had a family member who did, and the focus of the railroads was the three major docks of Ashtabula's outer harbor: Pennsy Dock and New York Central's A&B Dock and Union Dock. Residents who were children in the 1930s, 1940s, and 1950s remember using company passes to travel, often taking the train to Cleveland to see a ball game. Views of the harbor in the mid-20th century show miles of track, hundreds of hopper cars filled with coal and iron ore, and three towering ore bridges defining the skyline.

What happened? The docks seem nearly silent today, and they appear almost deserted compared to years past, when they teemed with activity. These changes came about due to the mechanization of the loading and unloading process. It began with the McMylars in the 1890s, continued through the era of the great Huletts (1910 through the late 1970s), and culminated with the huge self-unloading ships of today.

But what most people do not realize is that Ashtabula is still a major port; in fact, Ashtabula now has the largest private dock on the Great Lakes. The second part of the Port of Ashtabula's story was shaped by the convergence of postwar industrial expansion, the new St. Lawrence Seaway, and the commitment of President Eisenhower to the expansion of the nation's highways in 1956. From 1945 to 1955, industrial firms spent roughly $300 million on new plants and development in the Ashtabula area, and the new industries were interested in bringing bulk materials in by boat and then trucking them directly to their plants. Ashtabula's docks were accessible only by rail.

Nelson J. Pinney was a general contractor and trucker in Ashtabula. Here is how *Electrical Production* magazine told the story of "Pinney's Piers" in 1954: "Several years back, National Distillers Chemical Corporation looked at the Ashtabula Area for a proposed metallic sodium plant. The company liked the location. One reason: salt, vital raw material, could be brought in by boat. That also led to a problem. Where can you unload salt on the Ashtabula River? . . . During a particularly enthusiastic moment, even for the enthusiastic Mr. Pinney, he promised to unload salt and deliver it to the Distillers plant. . . . 'I knew the Distillers operation would mean a lot to Ashtabula. So I felt this was one way of paying a debt to the city that has been so good to me,' says Pinney. 'But I sure didn't know it would be so hard to find a little room next to the river. What wasn't being used to unload iron ore and limestone was being used to load coal.' Pinney managed to find a toehold along the river, but he did not like working in cramped quarters, so he bought a sizeable chunk of land fronting on Lake Erie."

That land was the old Woodland Beach Park just east of the railroad docks, dormant since 1929. From 1952 to 1956, Nelson Pinney used waste material from the New York Central Railroad, slag from Electromet's carbide and ferro-alloy operation, and the fill created by leveling the bluff fronting on the lake to construct two 2,000-foot piers. Pinney Dock accepted its first cargo in 1956.

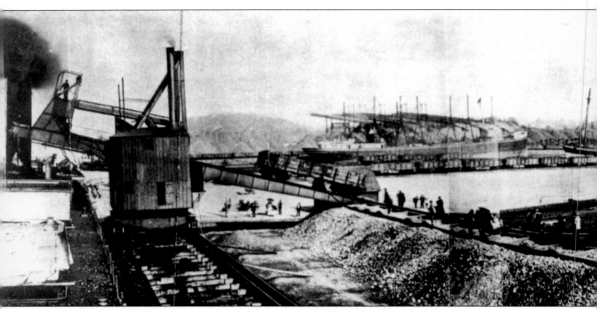

McMylar Car Dumping Machine at Ashtabula Harbor. Most of the shipping activity of the late 19th century occurred on the Ashtabula River at the inner harbor. By the 1870s, the Pittsburgh, Youngstown and Ashtabula Railroad (PY&A) had the right of way on the west side of the river, while the Lake Shore and Michigan Southern Railroad (LS&M) had the east side. The first ore docks were built south of the railroad bridge, and cargo was unloaded by hand. By the 1890s, the ore ships were becoming too big to navigate the river beyond the bend just south of Fifth (Bridge) Street. The LS&M built the Minnesota Slip on the east side of its river dock, and the PY&A put docks on the west side of the river north of the bridge. The LS&M also built docks on the east side of the Minnesota Slip and extended it out into the lake. In 1908, the city extended the river channel south of the railroad lift bridge and agreed to swap Point Park for railroad land south of the bridge so that Great Lakes Engineering Works of Detroit could establish the Ashtabula shipyards. Mechanization continued to replace manpower, but at the same time, the huge expansion of the railroads and their docks continued to provide local jobs. (Reproduced by Richard Stoner from the *Marine Review*, September 9, 1894.)

THE CAR DUMPER. The successors to the McMylar car dumping machine, these "tipples" could pick up an entire hopper car and dump it into the hold of a ship. The first one was installed on the Pennsy Dock in 1916. (Vinton N. Herron photograph, courtesy Florence Stoner.)

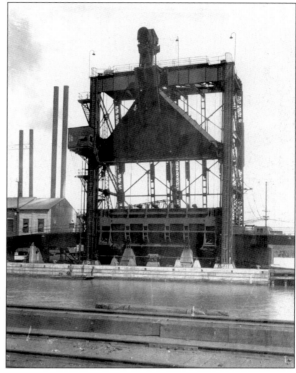

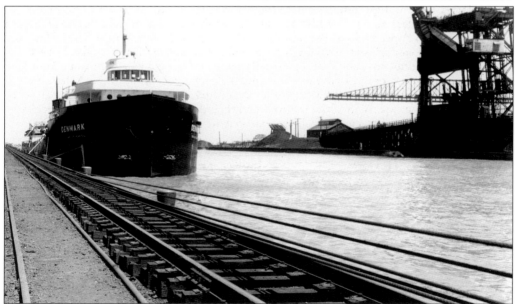

THE MINNESOTA SLIP. In this 1970s-era photograph, the *Denmark* is on the unloading (east) side of the A&B Dock. Across the slip is the Union Dock's tipple, with the ore bridge behind. Also visible is the ore sampling building, which became obsolete when iron ore began to be shipped as pellets in the 1980s. Since the grade of the pellets was already known, ore samplers were no longer needed, and the docks lost yet more jobs. (Richard Stoner photograph.)

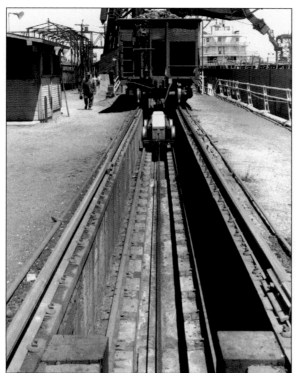

THE "PIG" AT PENNSY DOCK. As a carload is being emptied into the ship at the right, a full hopper is ready to be pushed up onto the platform of the tipple by this mechanical device. This full car will push the empty one, ridden by a "roughrider," down the other side. The roughriders had one of the most dangerous jobs on the docks. (Richard Stoner photograph.)

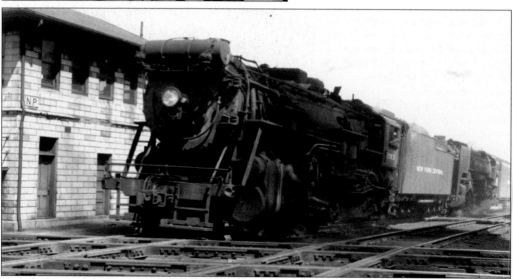

A STEAM LOCOMOTIVE APPROACHES THE NICKEL PLATE TOWER. This New York Central train, loaded with iron ore, is heading south toward Carson Yards in Jefferson. The cross tracks were constructed by the Nickel Plate Railroad, which later merged with Norfolk and Western. The railroad agreed to keep the Ashtabula routes of the former Nickel Plate open, a promise Norfolk and Western tried to break in 1966. Pinney Dock protested to the Interstate Commerce Commission and won. The switch was located near West 52nd Street. (Richard Stoner photograph.)

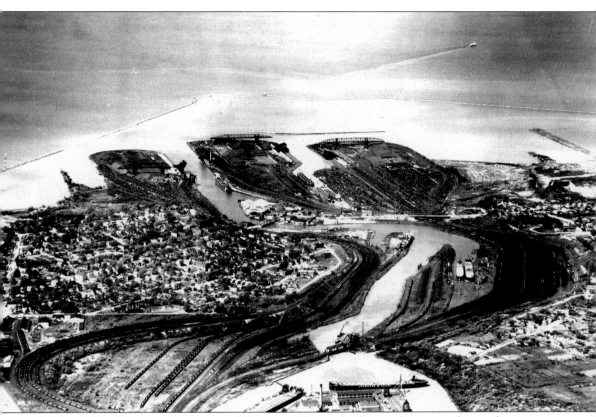

A Mid-1950s View of Ashtabula Harbor. The ore bridges and train tracks are dominant in this northward view; the Pennsy Dock is on the west side of the river, the A&B Dock is in the center east of the river and west of the Minnesota Slip, and the Union Dock is the easternmost. The Great Lakes Engineering Works shipyards are just south of the railroad lift bridge. To the east, Nelson Pinney's first two piers reach out into the lake. Pinney Dock and Transport Company was built to handle only self-unloading vessels, and was well positioned to service Ashtabula's growing east side industries. The N. J. Pinney Dock, the old Angeline Dock leased from the New York Central, is visible as the white area on the east bank of the river south of the Fifth Street lift bridge. Still to come were the St. Lawrence Seaway, the Labrador iron mines (opened in 1957), and the Conneaut to Cincinnati and Lake to River Highways (Interstates 90 and 71 and state Route 11). In 1957, work began on deepening the channels in the Great Lakes to 27 feet. When the channels in the lower lakes were completed in 1959, 90 percent of oceangoing vessels were able to navigate through the Welland Canal. By 1962, work on the Upper Lakes was complete. (Richard Stoner photograph.)

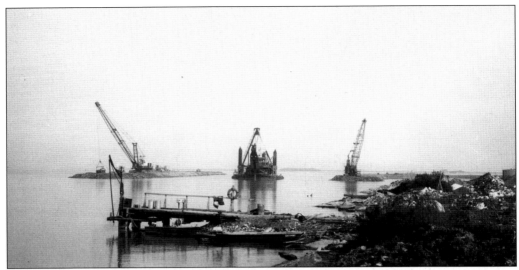

BEGINNING THE PINNEY DOCK SLIP. Although Pinney Dock was built westward from the easternmost pier, the slips and docks are numbered from west to east. The first pier built was what is now the cargo pier, Dock 4, followed by the Dock 3 half of the bulk pier. The first slip was Slip 2, located between them. (Dunbar and Sullivan Dredging Company photograph, courtesy Pinney Dock.)

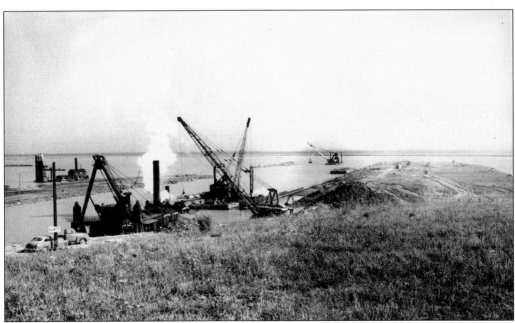

SLIP 2 IN 1955. Less than a year before Pinney Dock accepted its first cargo, dredging progresses on Slip 2. The outer harbor was dredged by Merritt, Chapman and Scott at the government's expense as part of the Seaway work. The work included the creation of a turning basin for the new docks. (Richard Stoner photograph.)

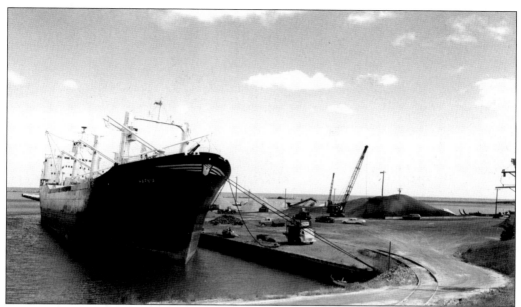

Seaway Trade. After the opening of the St. Lawrence Seaway in 1959, foreign ships such as the Norwegian *Hafnia* were frequent callers at the new docks in Ashtabula Harbor during the April–November shipping season. These saltwater ships risked being laid up for the winter if they failed to negotiate the Welland Canal and the St. Lawrence before the ice formed. (Richard Stoner photograph, courtesy Pinney Dock.)

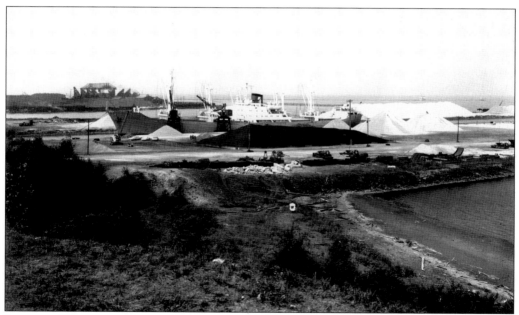

Looking West from Pinney Dock. A saltwater ship dwarfs the two gantry cranes unloading at Dock 4. Both piers are being used for bulk storage here, dating the photograph before 1963. On the skyline, the ore bridge and the Huletts rise above the New York Central's Union Dock. (Richard Stoner photograph.)

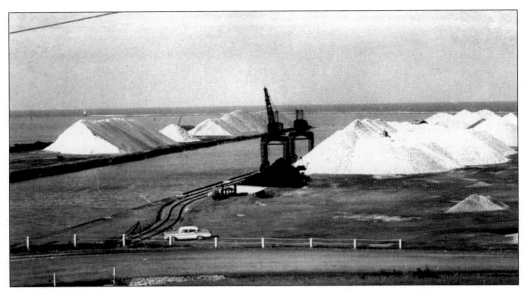

THE TWO 15-TON GANTRY CRANES. These cranes were equipped with buckets, hooks, or 66-inch magnets. In 1960, a joint venture, with Pinney Dock and Transport Company acting as stevedore, produced the first movement of shipload scrap in Ashtabula history. The Rochester Iron and Metal Company of New York sent the metal here for processing at the New York Central scrap yard, and the Hyman-Michaels Company of Chicago acted as charter agent to send the cargo to Japan and Taiwan. (Courtesy Pinney Dock.)

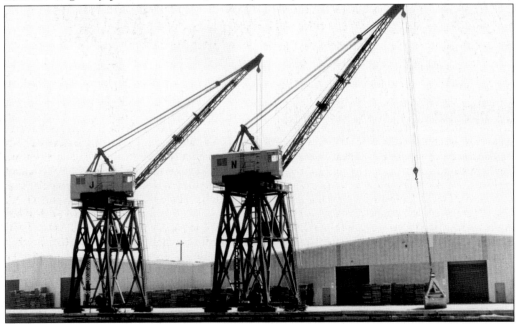

THE TRANSFORMATION TO A CARGO PIER. In this 1979 photograph, the cranes service the warehouses that were built on the Dock 4 pier, turning it from a bulk storage area into a cargo pier. By 1966, Pinney Dock had six warehouses and 232,000 square feet of storage. (Gale Compton photograph, courtesy Pinney Dock.)

54

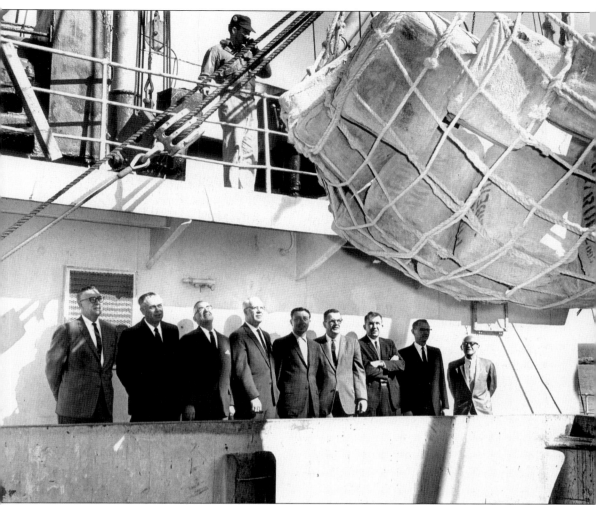

AFRICAN RUBBER ARRIVES, 1963. Members of the Ashtabula Chamber of Commerce join unidentified Akron rubber company executives to welcome a shipment. From left to right are Benham G. Cheney (Pinney Dock's director of sales), three unidentified Akron men, Samuel Goldstein of the Ashtabula Salvage Company, Warren Andrews of Ashtabula County Savings and Loan, David DeLuca (Ashtabula city manager), John Huggins of Iten Fibre, and A. C. "Pat" Patterson (executive vice president of the Ashtabula Chamber of Commerce). Rubber imports through the Port of Cleveland by Akron's rubber companies doubled from 1960 to 1961. Cleveland built the piers and leased them to the stevedoring companies, which had neither adequate storage nor efficient labor to handle the increased volume. In 1962, Nelson Pinney gambled on a new 44,000-square-foot warehouse and bid against the Cleveland Stevedore Company for the 1963 rubber trade. The new warehouse also increased capacity for other package cargo at Pinney Dock, such as lumber, newsprint, and pineapple. By the late 1970s, the Akron rubber companies had sent their manufacturing plants south, and with them went Pinney Dock's rubber trade. It became quicker and cheaper for the rubber to be brought into west and gulf coast ports by container ships, then shipped to the plants by rail. (Tobias Studio photograph, courtesy Pinney Dock.)

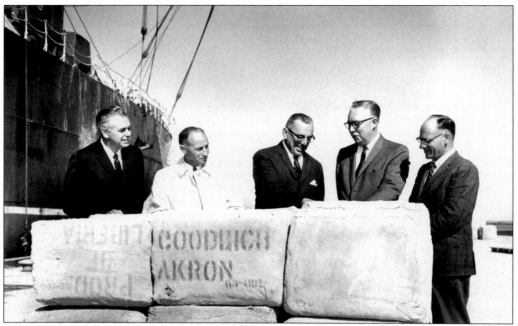

AN ONSHORE INSPECTION. Two unidentified Akron men join the Pinney Dock and Transport Company management team on Dock 4. From left to right are an unidentified man, Nelson J. Pinney (president), unidentified, Benham G. Cheney (director of sales), and Maynard Walker (dock supervisor). (Tobias Studio photograph, courtesy Pinney Dock.)

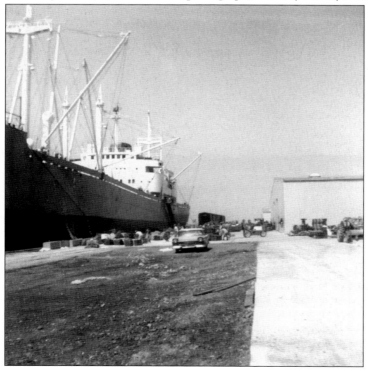

THE CARGO DOCK, MID-1960s. The foreign cargo coming via the Seaway also brought health and environmental risks, such as plant pests. The Department of Agriculture required inspection of every foreign ship at its first U.S. port of call. In 1969, county extension agent Lawrence Anderson Jr. quarantined an Indian ship when khapra beetles were found. The crew of 60 stayed at the Hotel Ashtabula while the ship was fumigated. (Courtesy Pinney Dock.)

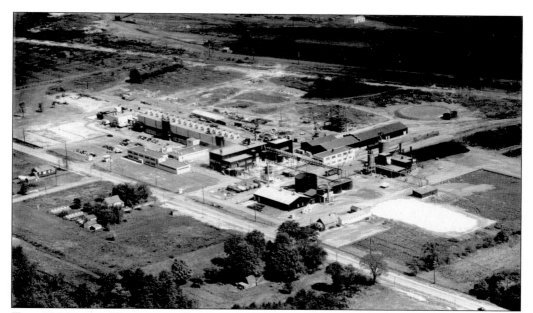

THE NATIONAL DISTILLERS CHEMICAL CORPORATION'S SODIUM PLANT. In this early photograph of the plant on State Road, the large salt pile is clearly visible. The plant was built in 1952–1954, and the N. J. Pinney Dock, operating on leased space on the Ashtabula River, began supplying 50,000 tons of salt a year. Salt was the cargo that brought the Pinney Dock and Transport Company into being. (Richard Stoner photograph.)

THE LAKE CITY MALLEABLE COMPANY. This metal castings plant, also located on State Road, operated through the war years with 400 to 500 employees. It was still producing its trademarked Shock Proof malleable iron in 1955. In 1957, the building was acquired by National Distillers, and it became Metals Reduction Company, producing titanium sponge. (Richard Stoner photograph.)

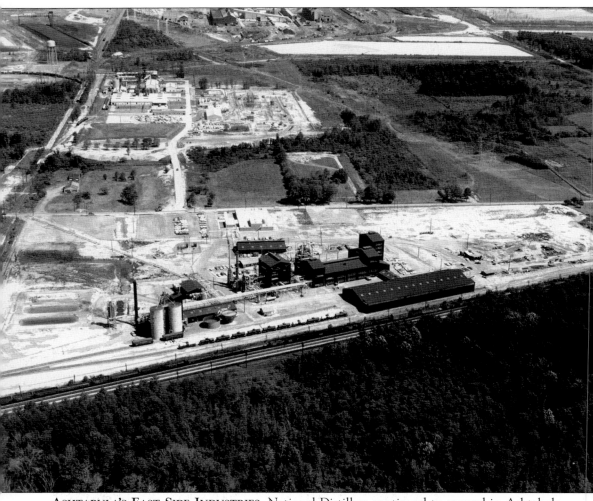

ASHTABULA'S EAST SIDE INDUSTRIES. National Distillers continued to expand in Ashtabula under the name Reactive Metals Inc. (RMI). RMI was owned equally by the National Distillers Chemical Corporation and the U.S. Steel Company. By 1968, RMI had a titanium plant and an extrusion plant on East 21st Street and the original plant on State Road (the black buildings seen here). Today only parts of the RMI extrusion plant remain. The company has been out of production and devoted to environmental cleanup for years. This photograph, taken before state Route 11 was built, shows us another major postwar employer. Electro Metallurgical Company (Electromet) was brought to Ashtabula by the government in 1943. By 1947, the Union Carbide Corporation had acquired it from the government, although the name Electromet was in use through the 1950s. The company manufactured calcium carbide, which was used to make acetylene gas, as well as various ferro-alloys that were used in the steelmaking process. Raw materials came in by boat, and by 1963, Pinney Dock was supplying limestone to Union Carbide Metals. In 1964, the Port of Ashtabula topped all U.S. seaway ports in bulk tonnage; 4.4 million tons passed through the three railroad docks and Pinney Dock. In July 1981, the Union Carbide operations were sold to Elkem A/S of Oslo, Norway, and became known as the Elkem Metals Company. Elkem closed its Ashtabula plant in 2004. (Richard Stoner photograph.)

THE FIRST LOAD OF LIMESTONE FOR UNION CARBIDE METALS. In July 1965, heavy truck traffic from Pinney Dock through the residential streets near the docks prompted increasing complaints and requests for a five-ton load limit on East Fifth Street, East Third Street, and Parkgate. Pinney Dock's attorney stated flatly that if the limit were enacted, 10 trucking firms and 25 industries would disappear. The controversy persisted for years, eventually alleviated by the completion of Route 11, the realignment of roads in the area, and Pinney Dock's acquisition of rail transport capability in the 1980s. (Courtesy Pinney Dock.)

UNION CARBIDE FURNACES. During the 1970s, the company temporarily used this mix house until a conveyor system became operational. (Richard Stoner photograph.)

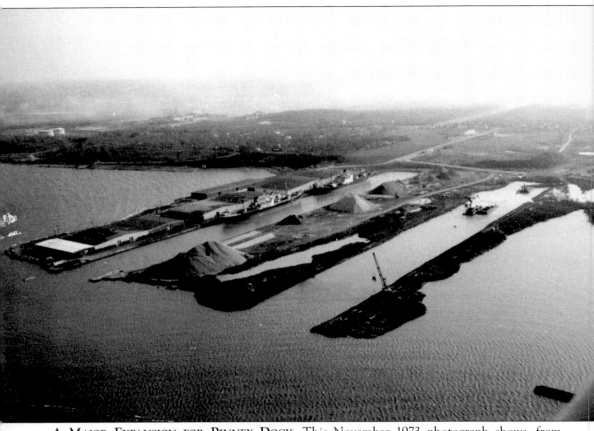

A MAJOR EXPANSION FOR PINNEY DOCK. This November 1973 photograph shows, from right to left (west to east), the building of Dock 1, the dredging of Slip 1, the expansion of the bulk pier and building of Dock 2, Dock 3, Slip 2, and two ships at Dock 4 on the cargo pier. These improvements doubled the capacity of Pinney Dock. Visible in the distance is the newly completed state Route 11. From the mid-1950s, there was a close partnership between the city and Pinney Dock. In 1957, the Lake to River Highway was on the state's drawing board, with its northern terminus planned to be an interchange at the intersection of East Sixth Street and Lake Road just east of Columbus Avenue. In 1966, the Ashtabula Port Authority suggested that some changes be made to East Sixth Street, now known as state Route 531, and also to the Lake to River Highway, now known as Route 11. The terminus was moved farther eastward, a change one disgruntled resident described as "building a road for Mr. Pinney." (Richard Stoner photograph, courtesy Pinney Dock.)

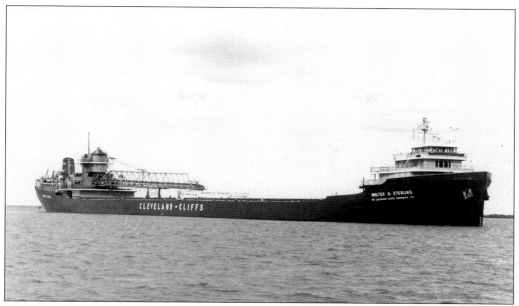

THE FIRST CLEVELAND-CLIFFS SELF-UNLOADER. The Cleveland-Cliffs Steamship Company began carrying ore on the Great Lakes in 1867. The company built the first steel steamers for the iron ore trade, the *Pontiac* and the *Frontenac*, which called often at Ashtabula. But the company had no self-unloading ships until 1978, when the *Walter A. Sterling* was converted. Cleveland-Cliffs phased out its maritime department in the 1980s. (Richard Stoner photograph.)

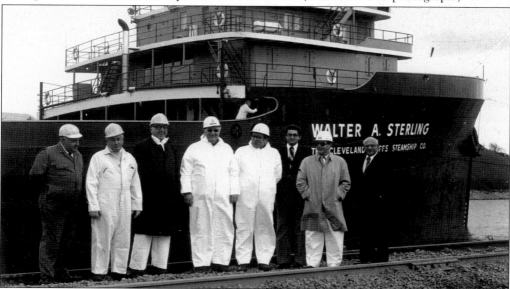

ARRIVING AT PINNEY DOCK. Ship personnel, wearing hard hats, join dock management to mark the first docking of a Cleveland-Cliffs vessel. By 1978, Conrail had replaced the bankrupt Penn Central Railroad and closed the Union Dock. At the far right is Maynard Walker, president. Nelson Pinney passed away in 1967, and Walker, his nephew, took over the business he had helped his uncle create. Third from the right is Joseph DelPriore, director of sales, who became president of Pinney Dock and Transport Company in 2001. (Richard Stoner photograph.)

A New Look for the Ashtabula Harbor. In this late-1970s or early-1980s photograph, the harbor skyline is defined by the coal conveyor belt, built in 1967–1968. Coal was unloaded from railroad hopper cars on the A&B Dock on the east side of the river, then transferred to await ships on the west side at the Pennsy Dock. In the 1950s, Nelson Pinney had tried unsuccessfully to negotiate a competitive rail shipping rate with the New York Central so that his new dock could accept iron ore and ship it out by rail. By the mid 1970s, ore was being brought into Pinney Dock by self-unloading ships and moved out via truck, adding to the already heavy truck traffic between the docks and Route 11. Once again the company tried negotiating a rail rate, this time with the Pittsburgh and Lake Erie Railroad (P&LE). It was discovered that the favorable shipping rates the railroads offered, which kept private docks such as Pinney Dock out of the iron ore business, were the result of antitrust violations. Pinney Dock filed suit, joined by Litton Industries, the manufacturer of self-unloading equipment for the shipping industry. Pinney Dock settled in 1980, but the Pinney-Litton case was not resolved before the Supreme Court until 1998. During the winter of 1980, Conrail removed its ore bridge and tracks from the Union Dock; Pinney Dock had acquired it, and began shipping iron ore from this dock by rail in 1981. (Richard Stoner photograph, courtesy Pinney Dock.)

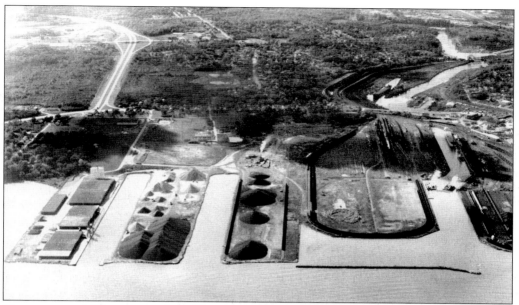

DREDGING THE MINNESOTA SLIP. The slip was built in two stages. The southern part, the jog behind the dredges, marks the extent of the docks in the 1890s. In the early 20th century, the LS&M docks were extended farther into the lake, and the slip was lengthened to add another dock. After acquiring the old Union Dock, Pinney Dock partnered with Conrail to dredge the outer part of the slip. (Richard Stoner photograph, courtesy Pinney Dock.)

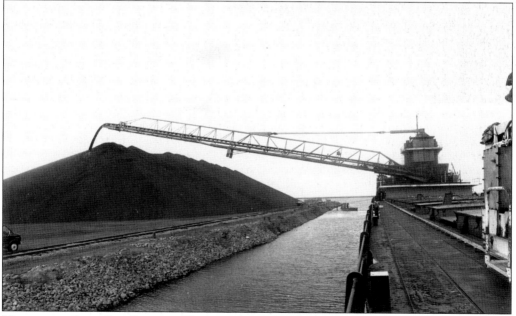

UNLOADING IRON ORE PELLETS. This ore carrier is berthed at Pinney Dock 1 at the westernmost pier sometime in the late 1980s. The size of the ship and the ore pile can be gauged by the vehicle at the far left. The great self-unloading ships come into port and unload in a few hours. (Richard Stoner photograph.)

63

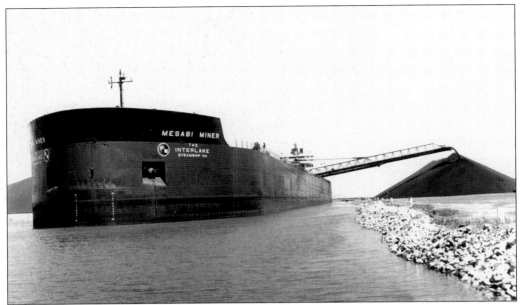

THE 1,000-FOOT ORE BOATS. The *Mesabi Miner* is shown here in 1979. Both Great Lakes and saltwater vessels steadily increased in size; by 1996, only 20 percent of the saltwater ships were able to negotiate the 26-foot Welland Canal in order to reach the lakes. Lake trade required ever deeper water and longer slips and could not be accommodated in the Ashtabula River. (Gale Compton photograph, courtesy Pinney Dock.)

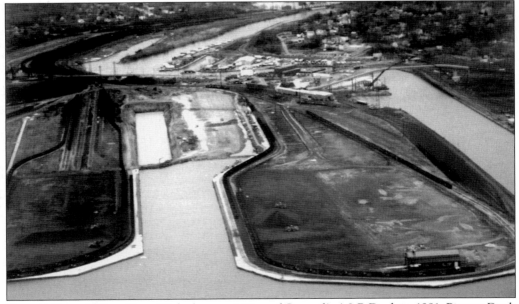

PINNEY DOCK'S NEW SLIP. With the acquisition of Conrail's A&B Dock in 1991, Pinney Dock gained ownership of the Minnesota Slip. The company straightened the slip by excavating the western part of the Union Dock and dumping it into the original 1890s LS&M Minnesota Slip. Built and named when Minnesota's Mesabi Iron Mines were first opened, Pinney Dock's New Slip still accommodates ore ships. (Courtesy Pinney Dock.)

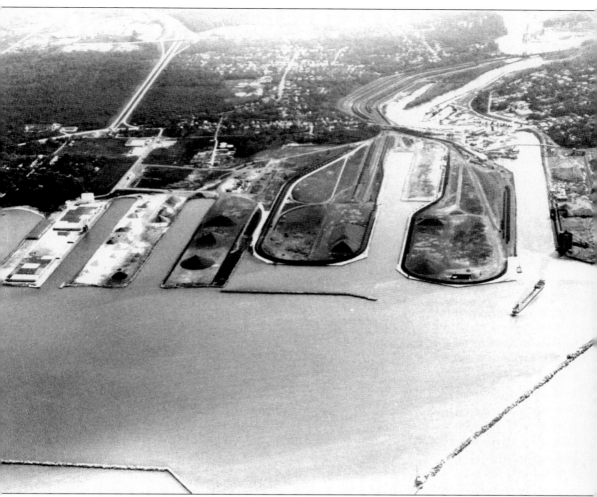

ASHTABULA HARBOR AT THE END OF THE 20TH CENTURY. The old Pennsy Dock (far right) is the only part of the harbor still owned by the railroad. Conrail, formed by the government in 1976 out of the bankrupt Penn Central, was split between CSX and Norfolk Southern 20 years later. The two have now merged, and just one railroad operates the coal yards on the west side of the Ashtabula River. Everything east of the river is now part of Pinney Dock and Transport Company, the business Nelson J. Pinney began when he leased the old Angeline Dock and then purchased the vacant Woodland Beach Park in 1952. Maynard Walker sold to Kinder Morgan in 2001, and in 2002, the Foreign Trade Zone first proposed for Ashtabula Harbor in the 1960s became reality. Ashtabula is no longer a railroad town, but it is still a port town. Pinney Dock and Transport handles approximately five million tons of bulk products a year. The decline of the railroad docks was beginning even as the St. Lawrence Seaway opened in 1959, driven by technological advances in self-unloading equipment for ever larger ships. The personal automobile and the developing airline industry doomed passenger rail service, and massive federal and state investments in highway projects fed the growing dominance of the trucking industry. The future of Ashtabula's Seaway Port of Progress turned out differently than the leaders of the mid-20th century could have imagined. (Courtesy Pinney Dock.)

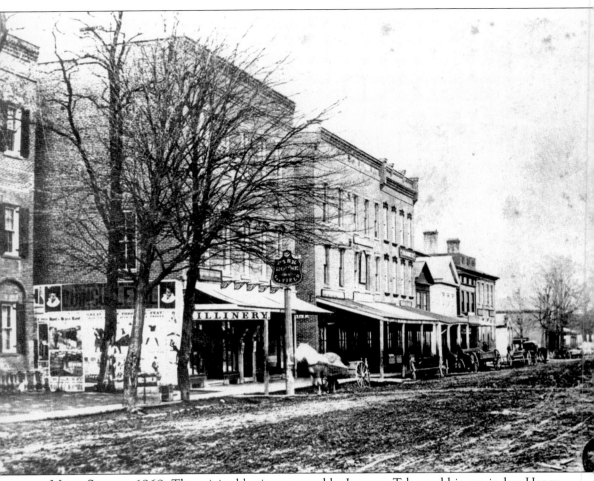

MAIN STREET, 1868. The original business owned by Lorenzo Tyler and his son-in-law Henry Theodore Carlisle (who went by the name Theodore) was located on the west side between Center Street and Progress Place, just across from Spring (West 46th) Street. One of the two frame buildings visible here was probably the Lewis P. Collins dry goods store, and the other was the original Carlisle family store. Lorenzo Tyler came to Ashtabula in 1846 and became the proprietor of an existing tavern on the corner of Spring and Main Streets. Family tradition has it that the Tylers left the tavern business for the dry goods business when they became concerned about the possible effects of the tavern environment on their daughter Mary Elizabeth. Lorenzo Tyler partnered with L. P. Collins in 1857, and the Tylers moved from the tavern to a house on Main Street next door to Frederick and Emmeline Carlisle. When Mary Elizabeth married their son Theodore c. 1865, Lorenzo Tyler bought out Collins's share and became senior partner in the firm of Tyler and Carlisle. Collins continued to operate a dry goods store for some years. In the 1930s, Carlisle's began holding anniversary sales, using 1868 as the founding date. The mistake was eventually discovered, but it was too late to change. Carlisle's celebrated its 100th anniversary in 1968.

Three

CARLISLE'S DEPARTMENT STORE
A BUSINESS THAT GREW UP WITH THE CITY

The Tyler and Carlisle dry goods store opened in the mid-19th-century village of Ashtabula during a period when the harbor was in decline. In 1852, the Lake Shore and Southern Michigan railroad (later the New York Central) crossed northeastern Ohio without building a spur to Ashtabula Harbor. It was not until 1873 that the Pennsylvania, Youngstown and Ashtabula Railroad built up to the harbor. West side harbor activity started when a brush-filled gully was leveled and business blocks were put up on the new Bridge Street. The harbor became part of Ashtabula in 1877, but the first link with uptown was not made until 1882, when horse trolleys began service.

In 1874, the store now known as Carlisle and Tyler moved to a brand-new brick building at 127 Main Street. By the end of the century, the Tyler family was no longer part of the business. The harbor was now the major commercial district, and the father-and-son firm of H. T. and L. T. Carlisle opened on Bridge Street c. 1898. As increasing mechanization came to the harbor, Lorenzo Tyler Carlisle entered into partnership with Miles Allen in 1911, buying out the F. J. Wood Company and forming the Carlisle Company Department Stores at 163–165 Main Street and 75–77 Bridge Street. The harbor store closed in 1914, and in 1925 the partners built a new three-story building on Main Avenue and christened it the Carlisle-Allen Company. Allen retired in 1937. Lorenzo Tyler Carlisle weathered the Great Depression, and he oversaw the opening of the first branch store in 1939 and the addition of two more floors in 1941. The business expanded multiple times as the third generation of Carlisles—Ted, Ford, and Tyler—took complete ownership through the postwar boom years of the 1950s and early 1960s.

Technology was also changing the face of retail. America's vastly expanded highway system spawned strip shopping centers and urban renewal; both came to Ashtabula in the 1960s. The Carlisle-Allen Company accommodated the rise of the automobile and then survived the closing of Main Avenue to traffic in the 1970s, when Arrowhead Mall was created. It also survived the rise of the discount stores. Lorenzo Tyler Carlisle III, known as Ren, became president in 1979, and through the 1980s the business continued to turn a profit and to expand in northeastern Ohio and western Pennsylvania.

Main Avenue's retail district could not survive the arrival of the Ashtabula Mall, and the fourth generation of the family business could not compete in a retail industry that was increasingly dominated by mergers and national chains. In June 1993, the year of its 125th anniversary, Carlisle's opened a specialty women's store called Carlisle's Clothing Company in the mall, but by October of that year the company had entered Chapter 11 bankruptcy protection. A smaller and more profitable company emerged the following year, but it could no longer survive as an independent department store. The family sold to Peebles in 1996.

The harbor began emerging from decline in the late 1970s, with recreational boating replacing shipping and specialty shops on West Fifth (Bridge) Street replacing the saloons and brothels. In 2002, Ren Carlisle and wife Toni opened Carlisle's Home in the Harbor, just a few doors from the H. T. and L. T. Carlisle store of a century ago. Unless otherwise noted, all of the images in this chapter are courtesy of Ren Carlisle.

AN 1883 BILL FROM CARLISLE AND TYLER. By 1874, Lorenzo Tyler had retired and turned his share of Tyler and Carlisle over to his son Sam Tyler, making his son-in-law Theodore Carlisle the senior partner. The store became known as Carlisle and Tyler and moved out of its original frame building. Eliza Ray Carlisle, born to Henry Theodore and Mary Elizabeth Carlisle in 1868, wrote the following description of the early store: "Imagine a drygoods or department store without a single ready-to-wear article. Shelves and shelves were filled with piece goods, from velvets, silks and satins down to calicoes. Rayon and nylon were unknown. Hats could be bought only at a milliner's. After thirty, most ladies wore bonnets with strings; mantles and shawls of all types and sizes were worn; paisleys, crepes, laces and heavy woolens for winter. . . . Father put in long, dragged-out hours, from eight o'clock in the morning to nine o'clock at night. To have Father at home Sunday evening made a gala occasion of it. Father did his own bookkeeping until I was old enough to help with it. How simple it was: single-entry, and no Government reports or income taxes to figure."

A NEW LOCATION FOR CARLISLE AND TYLER. Druggist George Willard erected his fine new brick block at 127 Main Street in 1874. This building later housed Marshall's Drugs on the first floor and Richard Stoner's photography studio on the second floor. It still stands today. (Reproduced by Richard Stoner from the *History of Ashtabula County, Ohio, 1798–1878*.)

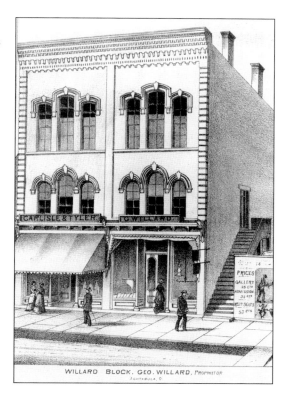

WILLARD BLOCK. GEO. WILLARD, PROPRIETOR
ASHTABULA, O.

GOING,

GOING,

GOING!

Satines at 5c, worth 12½c.
Pacific and American Prints. 4c.
Challies, 3½c.
Shilling Lawns at 7c.
Pine Apple Tissues, 7c.
Curtin Scrims, 7c.
Fine Brown Cotton, 5c,
All Summer Goods at Cost and Less than Cot

Ashtabula Dry Goods and
CARPET COMPANY.
H. T. CARLISLE & P. S. KEPLER, Managers.
Main Street, ———— Ashtabula, O.

AN ADVERTISEMENT FROM THE *KINGSVILLE TRIBUNE*, AUGUST 7, 1891. The partnership between Theodore Carlisle and his brother-in-law Sam Tyler was not a happy one. Eliza Ray Carlisle remembered those times: "It might have been about 1888 or 1889 when Father felt he must make some great business change. . . . So Father had a great 'going out of business' sale, cleaning up his merchandise with an auction; whereupon, the Carlisle & Tyler firm ceased to exist. . . . Father had only been out of business a short time when the great Cleveland wholesalers, Root & McBride . . . asked him to assume management of a store across the street from Father's former location . . . known as the Erie Store."

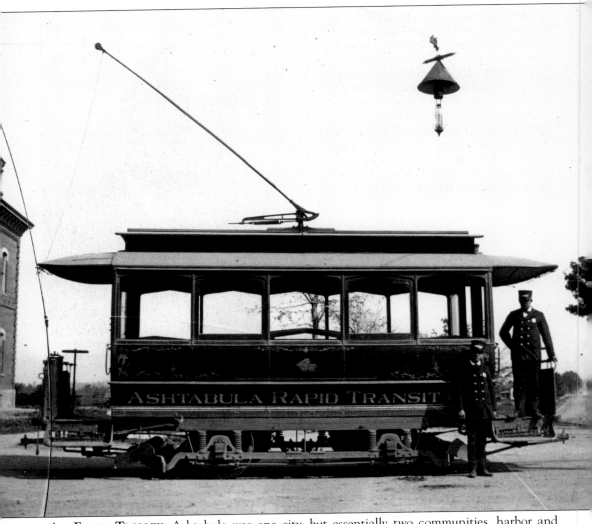

AN EARLY TROLLEY. Ashtabula was one city, but essentially two communities, harbor and uptown. From 1892 to 1938, the Ashtabula Rapid Transit lines ran between uptown and the harbor. Theodore Carlisle went back into business *c.* 1898, when son Lorenzo Tyler Carlisle convinced his father that the booming harbor was the place to be. The father-and-son firm of H. T. and L. T. Carlisle opened on Bridge Street. The staff was composed of Theodore and L. T., two or three salespeople, and a handyman. In 1901, Theodore Carlisle died suddenly of pneumonia, and L. T.'s eldest sister Eliza Ray "Betty" Carlisle joined her brother in the business to handle the books. She remembered her commute to the harbor from the Carlisle home: "The street-car line ended at Prospect and West Streets, and before going to Bridge Street, it rambled up to the car barns at the south end of Main Street—where the driver paused for refreshments while I twirled my thumbs. . . . Going home about 8:30 one blizzardy evening, I was stalled near the overhead bridge. . . . The snow was too deep for the car to proceed, too deep for me to navigate. . . . Finally a driver from Gregory's Livery came to my rescue with horse and sleigh." (Vinton N. Herron photograph, courtesy Florence Stoner.)

LORENZO TYLER CARLISLE, C. 1940.
The first Huletts came to Ashtabula harbor in 1910, and uptown was becoming more accessible, with better trolley service, paved roads, and the increasing use of automobiles. L. T. began to see that, in the long run, Ashtabula would have one business district: Main Street. He entered into partnership with Miles Allen in 1911, forming the Carlisle Company Department Stores at 163–165 Main Street at the southwest corner of Progress Place. (Vinton N. Herron portrait.)

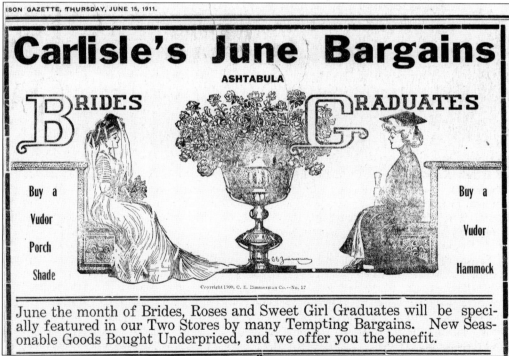

AN ADVERTISEMENT FROM THE *JEFFERSON GAZETTE*, JUNE 15, 1911. The new Carlisle Company briefly operated two stores, the old H. T. and L. T. Carlisle store on Bridge Street and the new uptown store. In 1914, the harbor store was sold to Sherm Eddy, and the decline of the harbor as a commercial center eventually put it out of business.

A Third Generation. Lori Carlisle and Ruth Ford married in 1900. In 1909, Lori's sister Betty contracted tuberculosis and went to Colorado Springs, where she and her sister Katherine, known as Kate, lived the rest of their lives. They made long visits to Ashtabula. The family remained close; this photograph of Lori and Ruth's sons may have been taken on a visit to Aunt Betty. Theodore Henry "Ted" Carlisle is on the left, and his brother Ford is to the right. The toddler with his back to the camera is most likely Lorenzo II, known as Tyler.

The Future President of Carlisle's. This is either L. T. Carlisle or his youngest son, Lorenzo II (known as Tyler). Lori ran the family business until his death in 1944, and Tyler was president from 1965 to 1979.

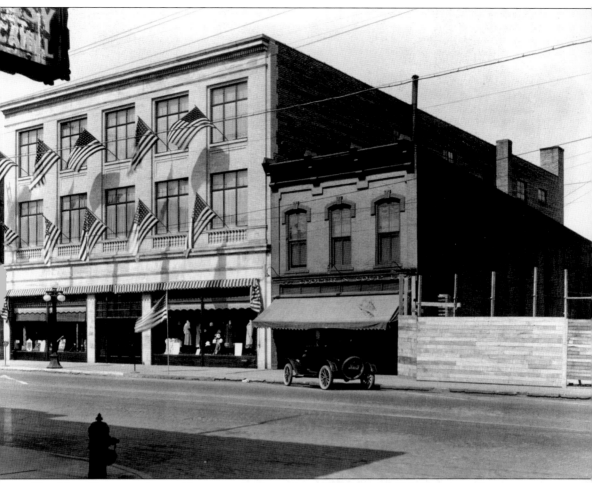

THE NEW CARLISLE-ALLEN COMPANY. In the spring of 1925, the Carlisle Company Department Store moved across Progress Place to a new building. Partners L. T. Carlisle and Miles Allen renamed the store in honor of the move. Tyler Carlisle later described his father's new store: "The original building was 60 feet by 135 feet deep, 3 floors plus a basement and a mezzanine. The main floor was terrazzo. There was a ladies rest room on the mezzanine and, most glamorous of all, there was an elevator. The building was sprinklered. The cash system was a Lamson pneumatic tube system with the tubes concealed in the false ceiling between the floors. I heard my father say one time that the building cost a total of $205,000." In this photograph, the new store still has no sign. At the left, the Kunkle Arcade, built in 1909 on the northwest corner of Progress Place, is still only two stories, though construction fencing indicates it was in the process of adding its new top floor. The fencing at the right marks the beginning construction of the Masonic Temple. The sidewalk flag is not unique to Carlisle's. The sidewalks all along Main Avenue were equipped with flag holders, and each merchant would start the day by washing down his sidewalk and putting out his flag.

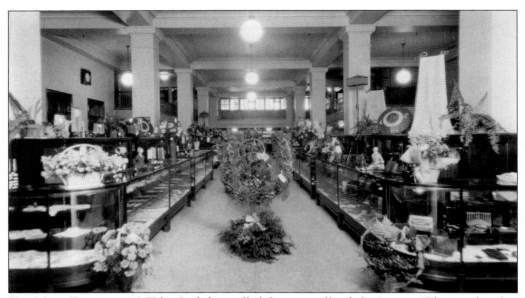

THE MAIN FLOOR, 1925. Tyler Carlisle recalled the setup of his father's store: "The merchandise presentation was essentially what it had been in the old store but more in depth. The basement was bedding and domestics. The main floor was hosiery, gloves, laces and trimmings, handkerchiefs, a jewelry department, a few cosmetics, a big notions department and yard goods. Second floor was ready-to-wear, millinery, corsets and lingerie. The third floor was Home Furnishings—carpet (27 inch, no such thing as broadloom), linoleum and draperies."

A HOSIERY ADVERTISEMENT, NOVEMBER 1925. This a page from a series of direct-mail magazines that the company sent out in the first year of the new store.

September~1925

CARLISLE MAGAZINES. These news magazines were developed with the help of a national retailing organization for aggressive promotion of the new store. They were bulk-mailed monthly and contained advertising, fashion advice, and even serialized short stories by such well-known contemporary authors as Mary Roberts Rinehart.

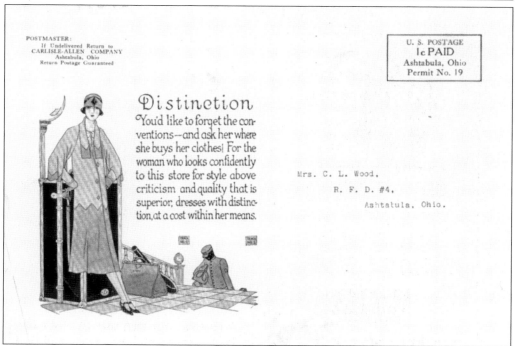

POSTMASTER:
If Undelivered Return to
CARLISLE-ALLEN COMPANY
Ashtabula, Ohio
Return Postage Guaranteed

U. S. POSTAGE
1c PAID
Ashtabula, Ohio
Permit No. 19

Distinction

You'd like to forget the conventions—and ask her where she buys her clothes! For the woman who looks confidently to this store for style above criticism and quality that is superior, dresses with distinction, at a cost within her means.

Mrs. C. L. Wood,
R. F. D. #4,
Ashtatula, Ohio.

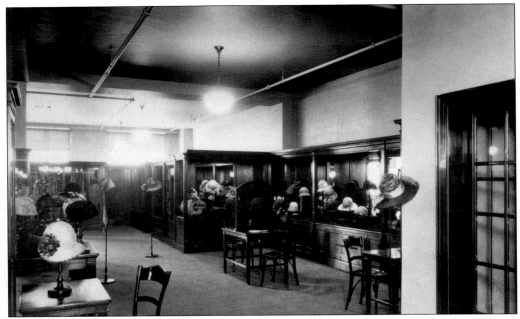

THE SECOND-FLOOR MILLINERY DEPARTMENT. It was no longer necessary to visit a milliner for a fashionable hat. Carlisle-Allen's millinery department could be reached either by stairway from the mezzanine or via the elevator. These spring hats were on display for the grand opening in April 1925.

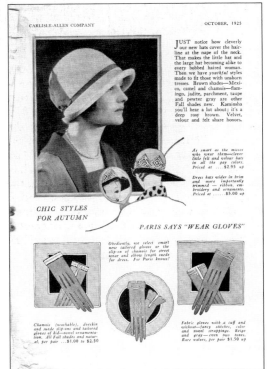

NEW LOOKS FOR AUTUMN 1925. As the year wore on, Carlisle-Allen customers were assured of receiving a heads-up on all the new season's styles and colors through the *Store News*.

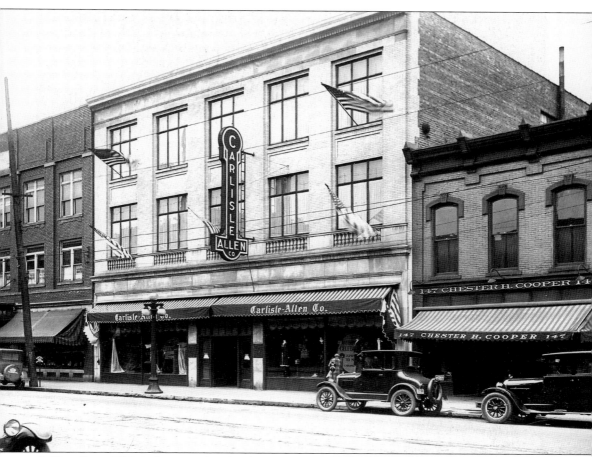

A NEW SIGN. This is the store shortly after opening in 1925. The Kunkle Arcade to the left was expanded to the level of the Carlisle-Allen building that same year. L. T. Carlisle and his partner actively promoted their establishment to the newly accessible suburban areas. A 1925 sales flyer includes a bus schedule on the back. The eldest of L. T. Carlisle's sons, Ted, went to work in the new store shortly after it opened. Brother Ford joined in 1931. In 1933, during the worst of the Depression, the store was open only from 11:00 a.m. to 4:00 p.m. A salesperson's pay was 25¢ an hour. In 1937, Miles Allen retired and sold his interest to Ted and Ford. When the outbreak of World War II ended the Depression, the brothers were ready to expand the store. In 1941, the fourth and fifth floors were built, adding almost 50 percent more space. When youngest brother Tyler joined the family firm just before Pearl Harbor, there were over 100 employees. Business remained good despite a chronic lack of help during the war years, and the company celebrated its 75th anniversary in 1943. A year later, in April 1944, Lorenzo Tyler Carlisle passed away. The company founded by his father passed to his sons.

AN ADVERTISEMENT FROM THE *ASHTABULA STAR BEACON*, APRIL 13, 1943. The 19th-century dry goods store was now fully developed into the modern department store. Carlisle's introduced many innovations to its operation over the years, from anniversary and special event sales to the self-serve basement, a creative way to cope with the war's labor shortage.

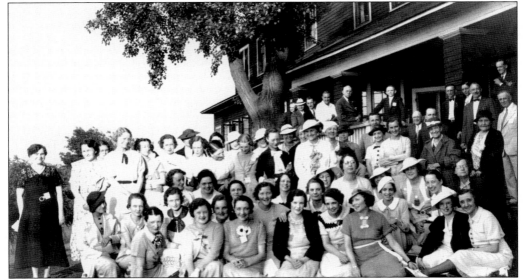

A STAFF GATHERING AT LAKE SHORE PARK HOTEL. L. T. Carlisle appears with a staff considerably larger than that of his first store, and one dominated by women. When his father's first store opened in the mid-19th century, all sales clerks were men; Theodore Carlisle hired Ashtabula's first female sales clerks. This photograph was probably taken in the late 1930s.

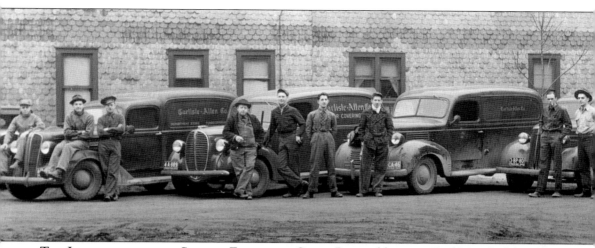

THE INSTALLATION AND SERVICE FLEET AND CREW. Pictured here are Fred Mossford (in the center, wearing a tie) and Larry Bucci (second from the left). The other men are unidentified. Carlisle's had been in the floor coverings business since the earliest years, and the fourth and fifth floors, added to the store in 1941, provided room to expand into furniture and appliances. This photograph of the delivery and installation crews was taken c. 1946 behind the store. The fleet of 1930s vehicles was not replaced until well after the war. In the background is an apartment building on Collins Court, which ran parallel between Main Avenue and Park Avenue, ending at Division Street (West 44th Street) in front of city hall. The first employee cafeteria was located in this building. In 1949, the store was extended back 60 feet in the basement, first floor, mezzanine, and second floor. Just five years later, the third, fourth, and fifth floors of the store were also extended back 60 feet. (Richard Stoner photograph.)

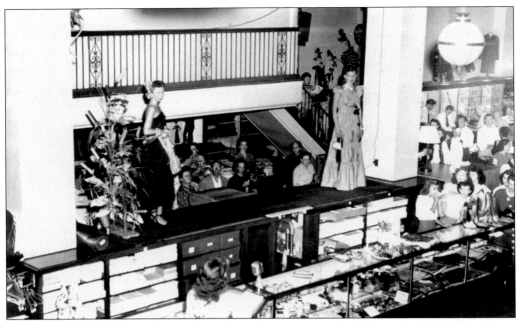

A FASHION SHOW ON THE MAIN FLOOR. Ashtabula's citizens, like all Americans in the postwar era, were anxious to forget the war and its shortages. Fashion was important again. In the era before television, department stores brought the latest looks to their customers with regular in-store fashion shows, such as this one on the main floor of Carlisle's. (Richard Stoner photograph.)

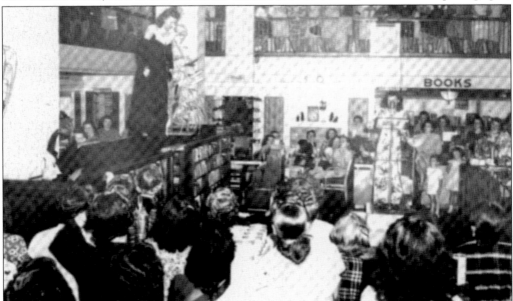

CARLISLE'S BEFORE THE REAR ADDITION. This fashion show must have taken place before 1949, because the store ends with the shoe and book departments at the original back wall of the 1925 building. Seated on a counter underneath the "books" sign, just to the right of the announcer, is Clare Carlisle, wife of Tyler. The two children standing in front of her are Lorenzo Tyler "Ren" Carlisle III and Casella "Cassie" Carlisle. (Richard Stoner photograph.)

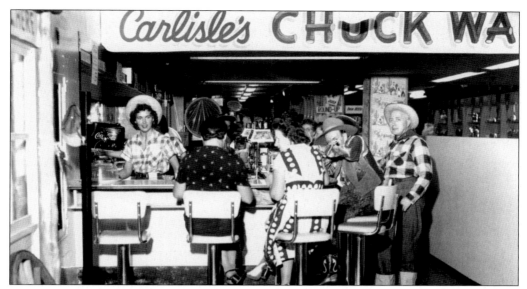

THE FIRST IN-STORE RESTAURANT. Sometime in the late 1940s, the Chuck Wagon Lunch Counter was installed in the basement. It proved extremely popular with customers, and Carlisle's maintained a restaurant in the store until well into the 1980s, when the Harbor Room closed. These western-garbed employees are perhaps costumed for Prairie Dog Days, the precursor to Main Avenue's Dog Days Festival. At the far right is Burt Brown, toy department manager. (Richard Stoner photograph.)

FORD CARLISLE AS COWPUNCHER. The three Carlisle brothers were very active managers and were often on the floor. Longtime shoppers remember being greeted by name regularly. (Richard Stoner photograph.)

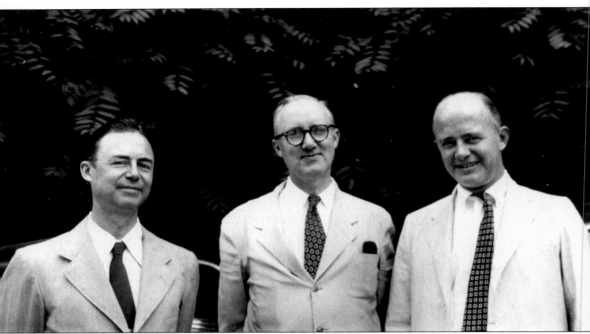

THE CARLISLE BROTHERS, 1950s. From left to right are Ted, Ford, and Tyler Carlisle. Under their management, Carlisle's not only expanded its Main Avenue location multiple times but also opened branch stores in both Ohio and Pennsylvania. In 1948, after the company had been reorganized from a partnership to a corporation, Ted became president, Ford became vice president, and Tyler became secretary-treasurer of Carlisle-Allen Company. Of that period, Tyler wrote: "Our organization was very informal and, by any standard, very loose. We wore lots of hats. Ted was president, general merchandise manager, and divisional merchandise manager of home furnishings. Ford was vice president and divisional merchandise manager of ready to wear. I was secretary-treasurer, store manager of Ashtabula, and divisional merchandise manager of a number of first floor departments. . . . We were inbred and totally unsophisticated but the overall expansionary influences were so great and with modern competition hardly started, we did well." It is also true that the Carlisle brothers continued to be forward thinking. From the end of the war through the 1960s, they steadily increased parking capacity. In 1966, when city hall was relocated, the whole block behind the store from West 44th Street to Progress Place became customer parking. This allowed the store to develop and survive the 1970s closing of Main Avenue. Ted was president of the company from 1948 until 1962, when brother Ford took over. Ford was president until 1965, when he pronounced himself happy to turn the presidency over to Tyler. Tyler remained president until 1979, when his son Ren Carlisle became president.

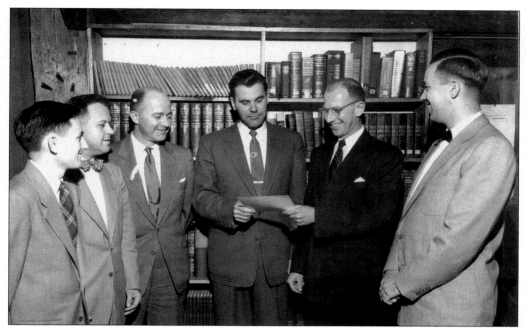

EXECUTIVE TRAINING. Pictured at the completion of a retail course in Pennsylvania *c.* 1954 are, from left to right, Ken Davern, Bill Wilson, Tyler Carlisle, Dick Johnson, unidentified, and Ed Anderson. The company invested in training its people well, and those people in turn often invested their entire careers with Carlisle's. (Courtesy Richard Johnson.)

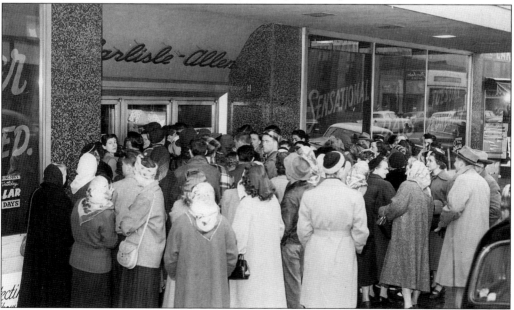

DOLLAR DAYS. Advertising limited-quantity items in advance of sales events guaranteed that large crowds would gather before the doors were open. Older residents remember plotting strategy, with each family member assigned to be in line for a different promotional item. (Richard Stoner photograph.)

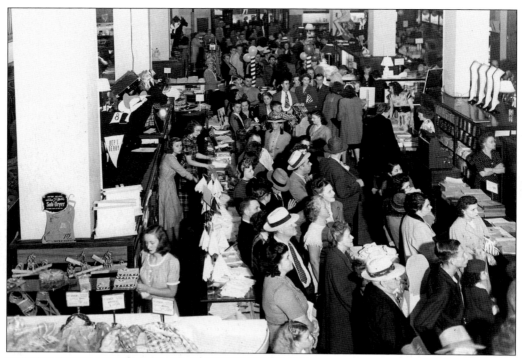

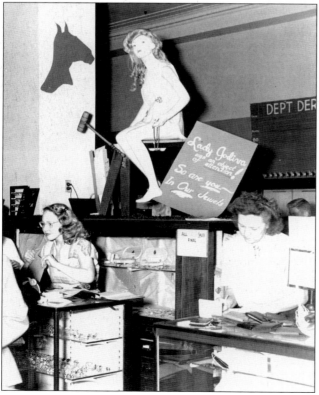

BRINGING IN THE CROWDS.
This crowd, viewed from the mezzanine, could have been on hand for any one of the many special sales events: the April Anniversary Sale, Ladies' Day, the Fourth of July, Dog Days, Back to School, or the Harvest Sale. The short-sleeved dresses worn by the clerks below, however, indicate that it was most likely a summer event. (Richard Stoner photograph.)

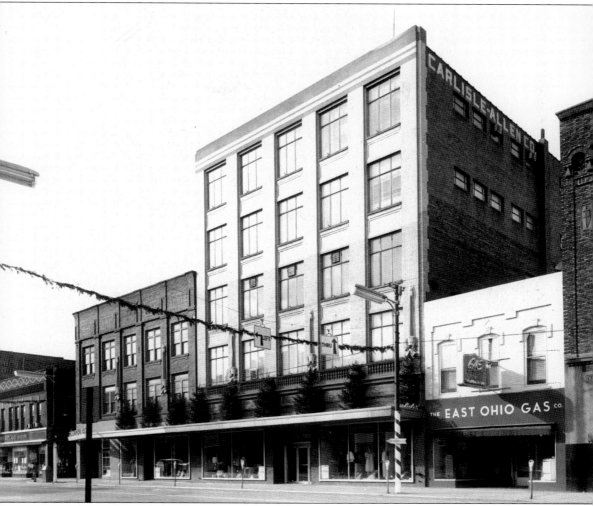

CARLISLE'S EXPANDED MAIN AVENUE STORE. The "modern" streetlight indicates that this photograph was probably taken in the mid-1960s. Visible at the left is the J. J. Newberry Company in the old F. J. Wood Company building, which housed the first Carlisle's store when the company returned to Main Street in 1911. In 1959, Carlisle's opened a new store for men in the Kunkle Arcade, which housed the bank and the men's store on the first floor, a stockbroker on the second floor, and Carlisle offices. In 1967, Carlisle's very first Electronic Data Department, developed by Dwight Beebe, was located on the second floor. Carlisle's eventually expanded to the north as well. Tyler Carlisle recalled the lengthy process: "With the start of 1969, Ford and Jim Hill initiated an expansion in Ashtabula. . . . This was the demolition of the Miner property between the store and the Masonic Temple, building basement, first floor, mezzanine, second and third floor space, new receiving and service areas in the rear with a new freight elevator and tying the three buildings together. . . . The result was very good and produced an Ashtabula plan that has remained essentially unchanged to this day." (Richard Stoner photograph.)

A SECOND-FLOOR FASHION SHOW.
Television did not become universal
in private homes until well into the
1960s. Carlisle's continued to bring
fashion to its customers, as these
1950s photographs illustrate. (Richard
Stoner photographs.)

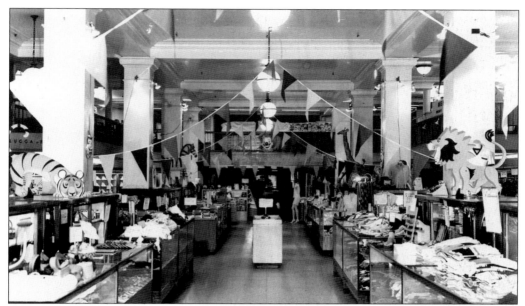

THE MAIN FLOOR, READY FOR A SALE. Merchandise is stacked ready on the counters for this circus-themed sale, but the sales force is not yet in position. The length of the skirt on the mannequin at the rear suggests that this photograph was taken sometime in the late 1960s or early 1970s. In August 1974, London declared the miniskirt dead, 10 years after its introduction. (Richard Stoner photograph.)

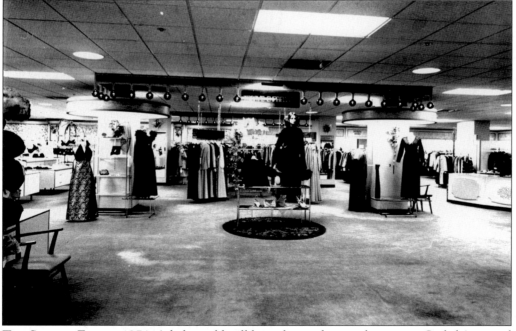

THE SECOND FLOOR, 1974. A lady could still buy a hat and so much more on Carlisle's second floor. This photograph was taken for an Ashtabula Chamber of Commerce brochure in 1974. (Richard Stoner photograph.)

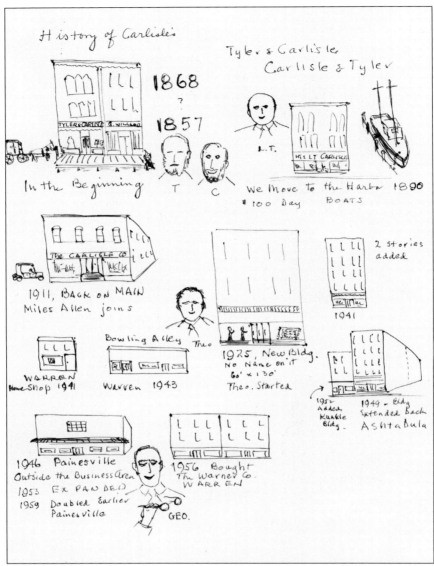

The sketch contains the following handwritten text:

History of Carlisle's

1868
?
1857

TYLER & CARLISLE G. WILLIAMS

In the Beginning
T C

Tyler & Carlisle
Carlisle & Tyler

L.T.

HI. LT. CARLISLE

We Move to the Harbor 1890
* 100 Day BOATS

2 stories added

1911, BACK ON MAIN
Miles Allen joins

The CARLISLE CO.

1941

Bowling Alley Theo

WARREN
Home Shop 1941 Warren 1943

1925, New Bldg.
No Name on it
60' x 130'
Theo. Started

1952 Added Kunkle Bldg.

1949 - Bldg. Extended Back
ASHtabula

1946 Painesville
Outside the Business Area
1053 EXPANDED
1959 Doubled Earlier
Painesville

1956 Bought
The Warner Co.
WARREN

GEO.

CARLISLE'S HISTORY IN OUTLINE. Ford Carlisle sketched out this summary of the company history c. 1970. This page recognizes the company's first branch store, the Warren Home Shop, opened in 1941, and the first Painesville store, opened in 1946. The sketch of "Geo." refers to George Haskell, who comanaged that store with Charles Winer. The warehouse mentioned at the top of the facing page was located on State Road in Ashtabula and supplied all the stores. Ford's brother Tyler, in his handwritten history, also recalled the 1960s: "The year of 1968 was a high water mark for the Company. The general recollection of the year is one of race riots, the violent Democratic convention and the Vietnam war. However, business and especially the retail business boomed. The Company turned in an 18% increase for the year . . . a record. The year was also the centennial anniversary for the Company and while it is difficult to define any particular benefit from the promotion, it did apparently generate public interest." Ford Carlisle passed away in 1975, before he could add the new Mill Creek Mall (1974) and Fort Steuben Mall (1975) stores to his graphic history.

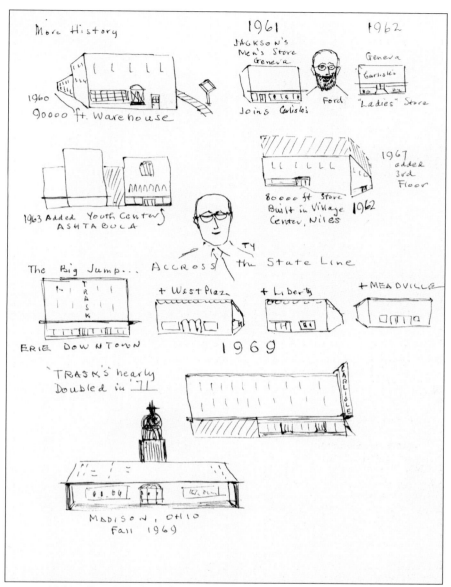

Handwritten notes within the image:

More History

1961
JACKSON'S Men's Store Geneva
Ford
Joins Carlisle's

1962
Geneva
Carlisle's
"Ladies" Store

1960
90000 ft. Warehouse

1963 Added Youth Centers
ASHTABULA

80000 ft. Store Built in Village Center, Niles 1962

1967 added 3rd Floor

TY

The Big Jump... ACCROSS the State Line

+ West Plaza + Liberty + MEADVILLE

TRASK

ERIE DOWNTOWN

1969

"TRASK's nearly Doubled in '71

CARLISLE

MADISON, OHIO
Fall 1969

BEYOND THE 1960S. By 1975, Carlisle's stores were in direct competition with malls in every location except Ashtabula. Tyler's handwritten history explains, "The principal reaction to the onslaught of the Malls was that we were convinced that the day of the 'small independent' department store was past. As a result, we would be determined to grow as fast as we possibly and profitably could." In 1979, Tyler became chairman of the board, and his son Ren became president. Their leadership sent the company in a new direction, closing some of the older, smaller stores and relocating to the major malls while also opening smaller apparel stores in new locations. The passing of both Ted and Tyler Carlisle in 1986 marked the end of 40 years of management by the third generation of the Carlisle-Allen Company, years characterized by personal involvement and sales growth. Company growth continued, with six new stores opening between 1987 and 1993, but the domination of the retail department store business by a handful of major conglomerates was almost complete.

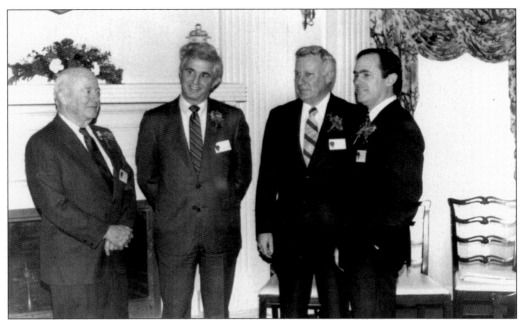

CELEBRATING A NEW STORE. The opening of the new fashion apparel store in Alliance's Carnation Mall in 1984 was the last one attended by chairman of the board Tyler Carlisle (far left). He is pictured here with two local people and his son Ren Carlisle, company president (far right).

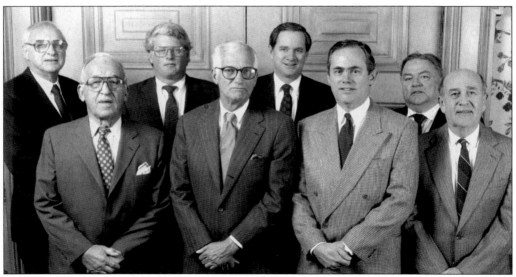

THE BOARD OF DIRECTORS, 1989. Pictured are, from left to right, the following: (first row) John F. Lebor, William S. Peebles III, Lorenzo Tyler Carlisle III, and E. Terry Warren; (second row) Albert M. Kronick, James P. McBrier, Marshall F. Wallach, and Albert T. Carlisle. Not pictured is Todd G. Cole. While Carlisle's was a privately held company, by 1980 the majority of the board was comprised of outside, independent directors. They faced multiple challenges, from the ever increasing dominance of national chains to the projected opening of the Ashtabula Mall. Just around the corner was the recession of the early 1990s. (Richard Stoner photograph.)

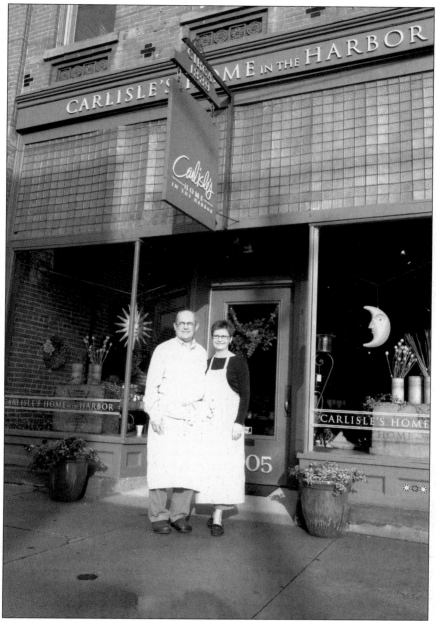

CARLISLE'S IN THE 21ST CENTURY. Ren Carlisle and his wife and business partner, Toni, stand in front of their new decorative home furnishings store. Carlisle's Home in the Harbor opened in 2002 just a few doors down from the location of the late-19th-century H. T. and L. T. Carlisle store. In the late 1980s, as Ashtabula County's overall economy continued to spiral downward from even "rust belt" status, Ren Carlisle led an initiative to found a countywide office to promote local economic development. In 1991, he was honored with the Best of the County President's Award for his work in establishing Growth Partnership for Ashtabula County. Since its founding in 1989, Growth Partnership has facilitated investments of more than $2 billion in Ashtabula County's business and industry.

CARLISLE'S STAFF DRESSED FOR SESQUICENTENNIAL WEEK. In a weeklong series of events from June 21 through June 27, 1953, the city of Ashtabula celebrated its 150th birthday. Carlisle's commemorated the event with historic window displays, special sales events, and this portrait of the costumed staff. As part of the citywide festivities, those who were not dressed in period

costume risked being thrown in the hoosegow for "Sesqui Violations." Their friends then had to bail them out with contributions. The next chapter further explores that extraordinary week in the life of the city.

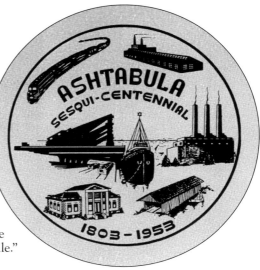

THE OFFICIAL SEAL. The May 15, 1953, edition of *Ashtabula Star Beacon* reported, "This seal, commemorating Ashtabula's Sesquicentennial Celebration, will be the official symbol during the year. It will be placed on all sesquicentennial coins, banners, and official souvenirs. The seal, which represents railroads, industry, power, shipping, cultural and historical features of the county, was drawn by Mrs. Winfield Frenelle." (Courtesy Florence Stoner.)

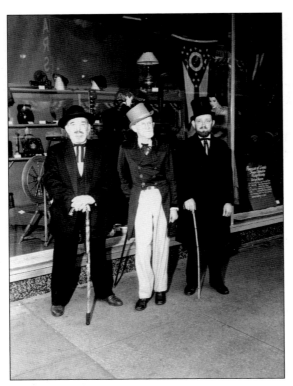

MAIN AVENUE DURING SESQUICENTENNIAL WEEK. Dressed to the nines in front of a historic window display are an unidentified person, Fred Santry, and Charles Hepler. Store employees enlisted antique and collection groups and prevailed upon friends to donate items, and show windows throughout the business district displayed collections of early Americana.

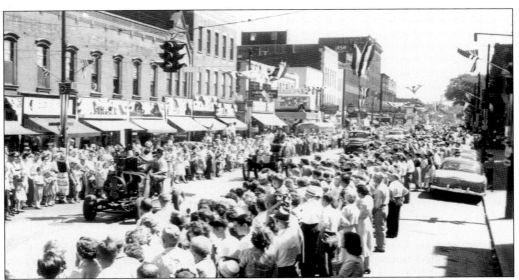

THE PARADE OF JUNE 27, 1953. According to the June 28, 1953, edition of the *Ashtabula Star Beacon*, "A. E. Wight, Ashtabula High School assistant principal piloted this home-made steam vehicle. His boiler fire left a cloud of smoke, but the odd contraption ran smoothly." Saturday's Labor, Industries and Organizations Day parade had 60 units, including 9 bands and 26 floats. Law enforcement agencies estimated a crowd of 15,000 to 20,000.

Four

ASHTABULA'S
SESQUICENTENNIAL WEEK
JUNE 21–27, 1953

In 1953, less than 10 years after the end of World War II, the state of Ohio turned 150 years old, and so did Ashtabula. Ike was president, and it was a time of general economic expansion, when Ohio's economy was robust and so were her cities, both large and small. The beginning of the 1950s was also the beginning of an economy that produced both leisure time and consumer goods for citizens as never before.

Is it any wonder, then, that a civic birthday party was cause for an elaborate weeklong celebration witnessed by crowds larger than the entire population of the city? The *Ashtabula Star Beacon* put it this way in its editorial of June 22, 1953: "The celebration is by far the most extravagant ever attempted here. Nightly pageants, a midway on a main thoroughfare, a series of parades including the longest on record, bearded citizens—these are only parts of the extravaganza. . . . For Ashtabulans, it will be a week of carnival spirit. This is their celebration. It will weld the community into camaraderie hitherto never attempted. . . . For visitors, it will be a chance to share in the friendliness of a small city. They will help us play. They will take part in the celebration we have planned for ourselves."

The event was a year in the planning, with significant involvement from the city government, the chamber of commerce, fraternal and social organizations, and businesses and industries. The Ashtabula Sesquicentennial Brothers of the Brush Committee was organized out of the Benevolent and Protective Order of Elks Lodge No. 208, and over 1,200 men paid the initiation fee. Deputies began "enforcing" whisker growing on May 22, and their hoosegow incarcerated many a luckless man who failed to grow whiskers or wear the official derby. Women were penalized for not observing the style rulings set down by the Emblem Club's Sisters of the Swish.

The week opened with a Sunday evening service with the theme "The Beginning and Growth of Religious Life in Ashtabula," which featured an all-city, 100-voice choir and addresses by Protestant, Catholic, and Jewish speakers. The Keystone Flag and Decorating Company of Philadelphia was contracted to decorate the business district for the event, and the John B. Rogers Producing Company was hired to produce the pageant, starring over 500 local residents, that played every night to crowds of up to 2,600. There were three parades, and special events were held for All County Day, Youth Day, All Nations Day, and Homecoming Day, including dances in the park and nightly fireworks displays.

Before there was a television in every home with hundreds of channels operating 24 hours a day, people found entertainment in working together and attending community events. Richard Stoner's photographic record of this week shows us what leisure time dedicated to community could produce half a century ago. Unless stated otherwise, all images in this chapter are by Richard Stoner and are courtesy of Florence Stoner.

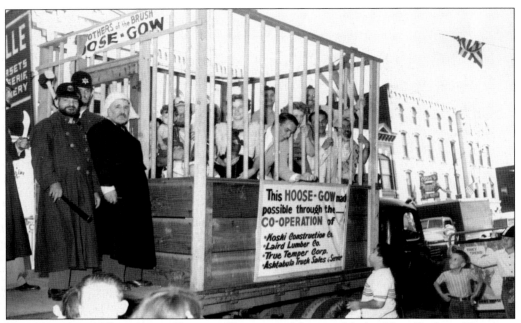

THE TRAVELING HOOSEGOW. Keystone Cops assist Municipal Judge Herc Paulino. Trying to raise bail from passersby with a hand through the bars is Congressman Oliver P. Bolton, who participated in opening ceremonies at noon on Monday, rode in the parade, and crowned the queen at the first performance of the pageant that evening.

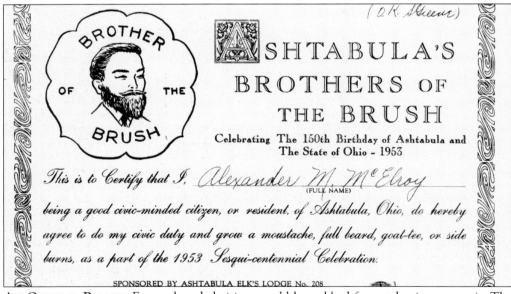

AN OFFICIAL PERMIT. Even a bearded citizen could be nabbed for not having a permit. The Brothers of the Brush participated in many events together, including an excursion train to a Cleveland Indians game. On June 10, some 1,100 brothers met at the Elks Temple on Park Avenue and marched to the New York Central station. They were joined by an additional 300 men when they left the train at a special siding in Cleveland, and it took 10 minutes for them to march into the stadium and around home plate. (Courtesy Andrew McElroy.)

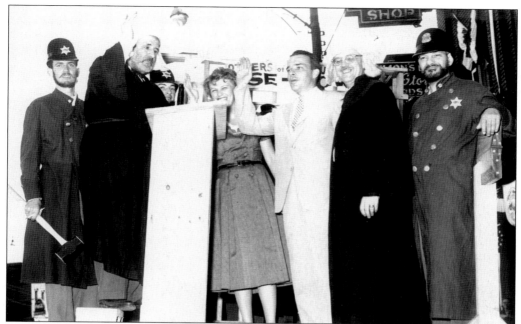

THE KANGAROO COURT. Ashtabula Municipal Judge Herc Paulino (left) swears in Congressman Oliver P. Bolton and his wife, assisted by a fellow "judge," local attorney Robert Koski. Bolton was put into the pillory for his "Sesqui Violation."

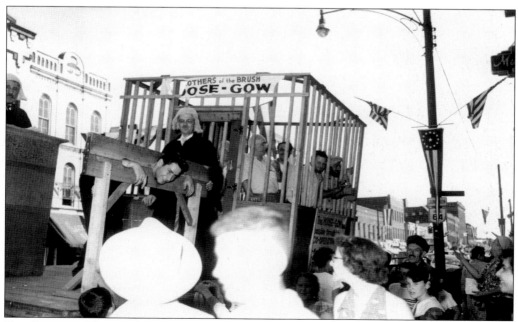

THE PILLORY. This unidentified clean-shaven citizen probably paid a fine as well as doing his time in the pillory; proceeds helped support the sesquicentennial events. The Kangaroo Court was a Friday evening event on Main Avenue during the month of June, and the rolling hoosegow was a prize-winning parade entry.

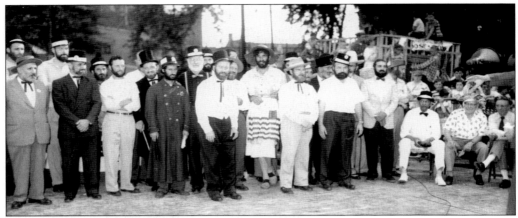

FRIDAY EVENING BEARD JUDGING, JUNE 26, 1953. Six barbers served as judges: E. D. Frayer of Jefferson and Ashtabula barbers Paul Carano, Steven Troxil, Dan Williams, Fred Fritz, and J. Walton McElroy. Thirteen prizes were awarded, including one "to the fellow who tried the hardest but couldn't raise a beard."

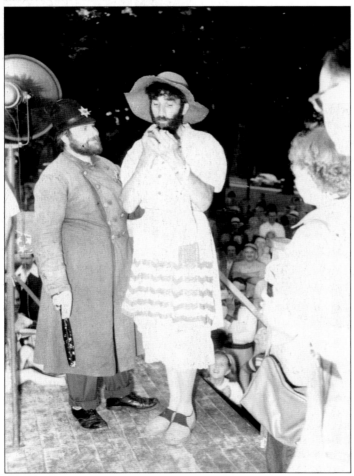

THE FINAL SESSION OF THE KANGAROO COURT. Court convened for the last time immediately preceding the judging. Is this a violation of the beard rules or the style rules?

The Most Distinguished Full Beard. Winner Harold Thompson waves to the crowd from the reviewing stand at North Park. With him is Joseph Kearney, president of the Ashtabula Sesquicentennial Brothers of the Brush Committee.

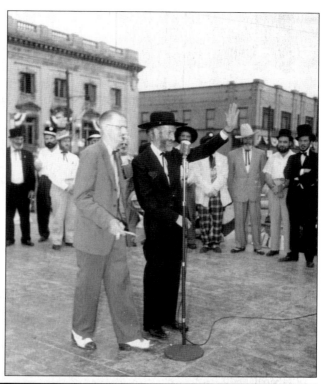

The Grand Finale. The June 27, 1953, edition of the *Ashtabula Star Beacon* reported, "Six Brothers of the Brush volunteered to shave their growths immediately after beard judging was concluded Friday. From left to right, beards came off A. C. Crawford, an unidentified man, Joseph Lovett, Louis Simon, Jack Fox, and Robert Lowther. Mr. Lovett walked off with top honors, having shaved his face clean in six minutes, 29 seconds." In the following Monday's paper, Langer Jewelers advertised a 14-day free shave test "On the Shaver That Removed the 60 Day Growth of Beard from the Contestants Faces."

A TWO-BLOCK MIDWAY. Standing at the south end of the midway are, from left to right, an unidentified person, Dale Tysinger (manager of Shea's Theatre), Albert "Bearcat" Camplese, and Don Van Allen (a postal worker). Main Avenue was closed from Park Place to West 42nd Street for the entire week.

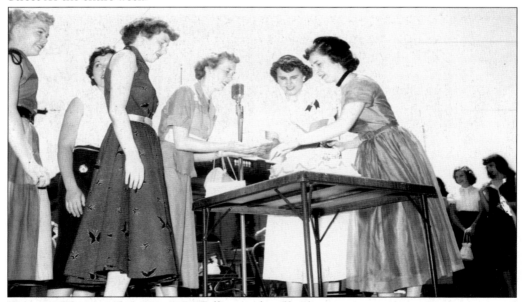

NOON ON MONDAY, JUNE 22, 1953. Following the official opening ceremonies, Sesquicentennial Queen Jane Ferrando (right) cuts the birthday cake, assisted by Duchess of Ashtabula County Glenna Graham (second from right). Attendants help serve; at the far left is Shirley Banning, and in the background at the far right is Leota Acierno. The queen, duchess, and attendants were chosen based on how many votes they received through ticket sales.

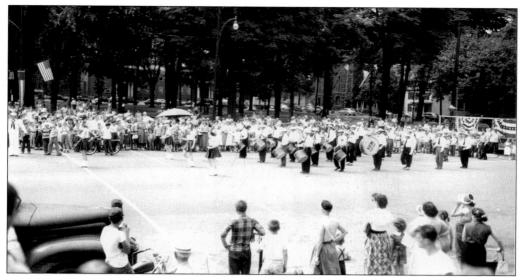

THE VFW DRUM AND BUGLE CORPS AT NORTH PARK. This group formed just three months before the sesquicentennial. In a city with two high schools, it was the natural choice to lead the parade. The head majorette (left) is Barbara Nieminen. The group stayed in existence for many years.

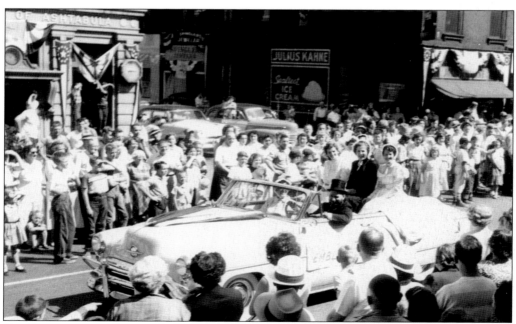

THE SISTERS OF THE SWISH. The Emblem Club organized the Sisters of the Swish, which held a style show on Friday afternoon before the Brothers of the Brush beard judging. Their 1953 Oldsmobile took second place in the decorated automobile category in Monday's Parade of Progress.

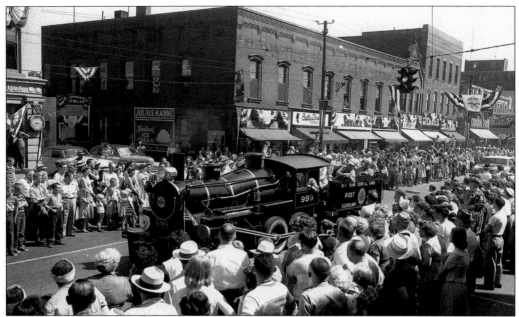

"OLD 999." This float commemorates the New York Central locomotive that set the land speed record in 1893, holding a speed of 112.5 miles per hour for six minutes. It was world news, and the engine was displayed at that year's World's Fair in Chicago. It also appeared at Ashtabula's West 35th Street Station during Sesquicentennial Week 60 years later.

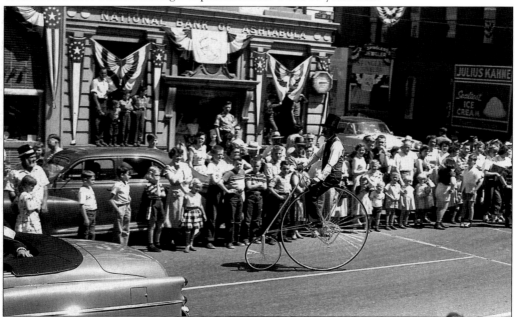

A BONESHAKER ON PARADE. The June 28, 1953, edition of the *Ashtabula Star Beacon* reported, "One of the hardest working parade participants was Albert H. Moses, Jefferson attorney, who donned a false mustache, high hat, and 19th century costume to ride his high wheeler up and down the parade route."

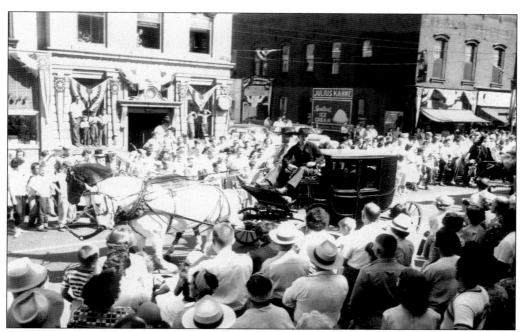

A HANSOM CAB. Horse-drawn vehicles were a very popular part of Monday's Parade of Progress. This cab was owned by Ducro Funeral Services.

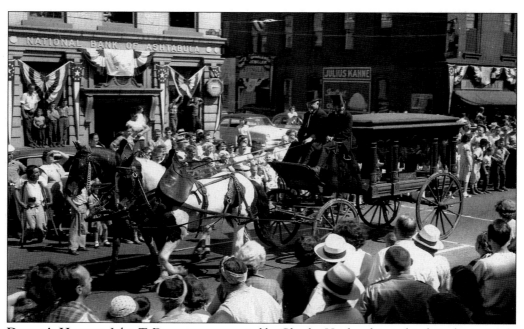

DUCRO'S HEARSE. John T. Ducro, accompanied by Charles Hepler, drives this first-place winner in the horse-drawn vehicles category. This *c.* 1875 platform spring wagon was found in a barn in Dover Center, Ohio; the funeral home that had used it had gone out of business. This vehicle is still in possession of Ducro Services.

AT THE LAKE AVENUE STUDIO. Director Dominic Massucci (in the white shirt and official sesquicentennial derby) founded Massucci's School of Accordions. His band played every Sunday on local television station WICA, which was in operation from 1952 to 1954; Ashtabula had a dance party show before Dick Clark's. The people taking third place in the decorated float category include Harry Corbissero, Ronald Kapala, James Montel, Barbara Vettel, Theresa Scufca, Phyllis Nappi, Larry Decker, Ronald Wolfe, Joey Dispenza, and Perry Volpone. (Courtesy Shirley Massucci.)

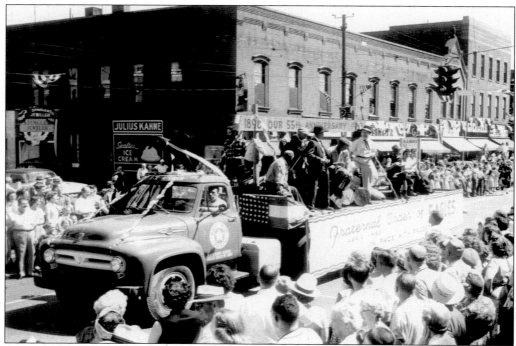

CELEBRATING THE 55TH ANNIVERSARY. Now over 100 years old, the Fraternal Order of Eagles Aerie 1483 still exists in Ashtabula.

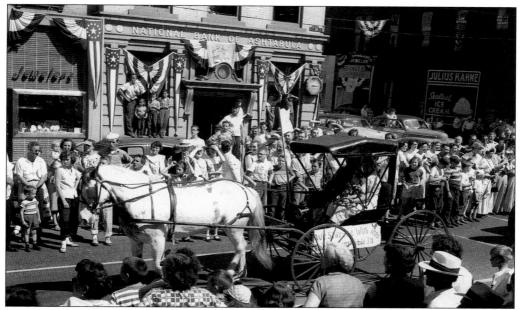

THE CARRIAGE BOW BECOMES THE BOW SOCKET. In 1880, carriage maker R. H. Pfaff became an officer in the Ashtabula Carriage Bow Company on Ann Avenue, which perfected a new design for the carriage bow, the mechanism that raised and lowered the canvas buggy covers of the day. The company successfully transitioned to the automobile industry during World War I, landing contracts with Ford, Chrysler, and General Motors to make convertible tops. The Ashtabula Bow Socket Company became nationally known in the automobile and bicycle industries. It was reorganized as ABS Industries in the 1970s. Although the company suddenly went out of business in the early 1980s, R. H. Pfaff's legacy remains in the Ashtabula Foundation, which he established in 1922 with a $5,000 investment. The foundation has grown through contributions to assets of $20 million. Its mission is to benefit Ashtabula County residents.

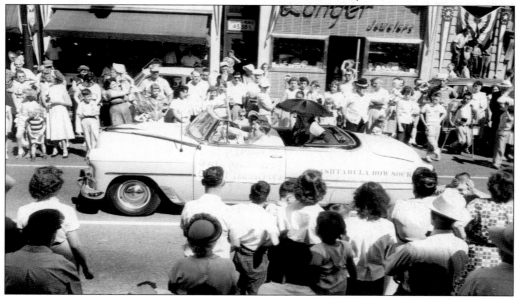

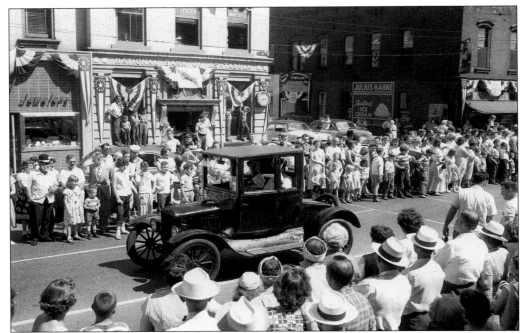

A BASIC MODEL T FORD. Henry Ford set out to make an automobile that was affordable, and this was the result. The basic model cost about $300, and Ford commented that customers could get one in any color they wanted, "as long as it's black."

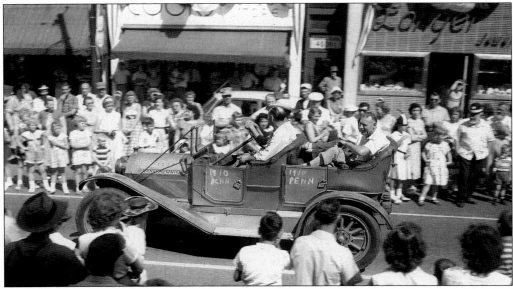

A RARE EARLY VEHICLE. Contrary to the hand-lettering here, the Penn 30 Touring Car was assembled in the Point Breeze section of Pittsburgh starting in 1911. In 1912, Penn moved its factory to Newcastle, but it lost its backers and ceased production. Fourteen years after this car appeared in Ashtabula's parade, it was sold, restored, and sold again. This car is now on display at the Frick Art and Historical Center in Pittsburgh, and the museum believes it is the only one on display in the world.

A 1913 Buick. The streetscape behind this "brass era" vehicle still exists. The building housing Richardson's Shoes and the large Peoples Building and Loan building to the right are vacant. Cedar's Grocery has become a dentist's office and has new siding. The Montgomery Ward building now houses the Outdoor Army Navy Store.

An Early Pontiac. In 1925, GM's Oakland Motor Company introduced a new car: "Pontiac, the Chief of the Sixes." The next year, 76,742 Pontiacs were built, and the brand quickly superceded the Oakland. The last Oakland was produced in 1931. The young boy standing in front of Cook's with his arms folded is Dominic Volpone, who went to work for Broughton Pepsi-Cola Bottling Company the summer he turned 16. He eventually became general manager of the company.

AN EMPLOYEE-MADE FLOAT. Pictured from left to right are Esther Anderson, Nancy Buckett Johnson, Eleanor Honkanen, and Virginia Mullen. These employees of Electro Metallurgical Company decorated this float by pushing pieces of construction paper into chicken wire. The ladies also had different outfits to wear in each of the parades.

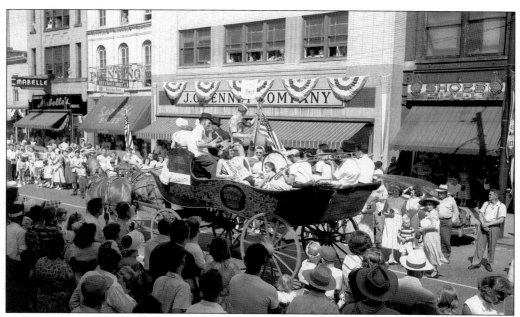

A BANDWAGON IN ORIGINAL CONDITION. Lenox Township's King's Cornet Band existed in its second organization from 1912 to 1919; it originally had been a Civil War brigade band. The band had this wagon built for $450. It is now owned by the Lenox Rural Museum.

THE THIRD-PLACE WINNER IN THE HORSE-DRAWN VEHICLES CATEGORY. The Painesville Coca-Cola Bottling Company was located on Valley View Drive on the east bank of the Ashtabula River. President Fred Knuebel was well known as a benefactor of Ashtabula's schoolchildren; if they brought their report cards to the plant, each "A" was rewarded with a gift, such as a new pencil or tablet. He also made summer jobs available to the youth of his church, Messiah Lutheran, and sponsored the popular Coke shows at Shea's Theatre during the summer, where admission and refreshments cost 10 bottle caps.

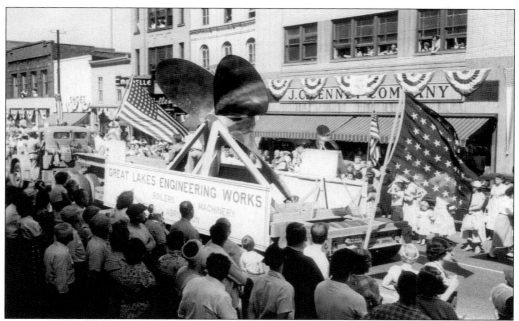

THE LABOR, INDUSTRIES AND ORGANIZATION PARADE FLOAT. This is an actual 18,795-pound solid bronze propeller from a Great Lakes freighter. It had a pitch of 14 feet 9 inches and a 16-foot diameter. At the time of the parade on June 27, 1953, the newspaper reported its value as $10,000.

ONE OF MANY OUT-OF-TOWN UNITS. Leisy's Brewery flourished in Cleveland from 1873 to 1923, when it was idled by Prohibition. Like most breweries in the highly competitive business, it sought to protect sales with exclusive placement in saloons. Ashtabula was a part of its market thanks to the railroad access. This was the second-place winner in the horse-drawn vehicles category in Monday's Parade of Progress.

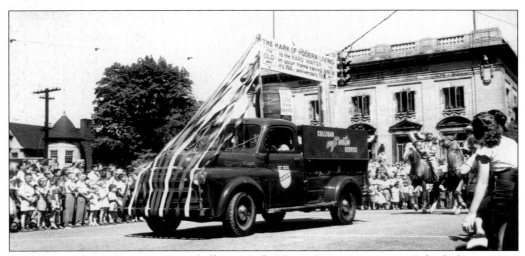

ASHTABULA'S CULLIGAN MAN. Culligan Soft Water Service came to Ashtabula in 1946. Ashtabula's first waterworks was completed in 1888 by Italian immigrant labor, but the extension of city water to the area outside the city limits by private companies was a much slower process. Even today, many of Ashtabula County's residents rely on wells, and much of the groundwater in the area is full of minerals.

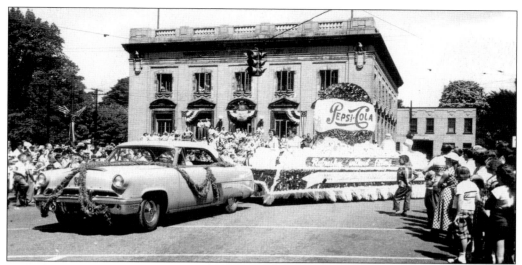

THE PEPSI-COLA FLOAT. Edward Broughton was president of the chamber of commerce in 1953. The Broughton Pepsi-Cola Bottling Company won second place in the decorated float category in Monday's Parade of Progress.

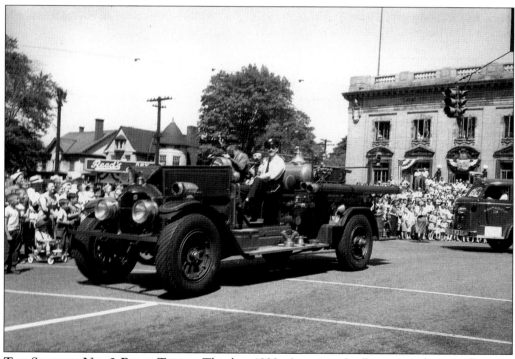

THE STATION NO. 2 PUMP TRUCK. This late-1920s American La France truck was still in use by the harbor fire station at the time of the parade. Riding along with Harry McClimans (in the white shirt) is the harbor station Dalmatian, Duchess. Just visible behind the float is the cab of the 1951 La France truck, one of the first covered-cab fire trucks.

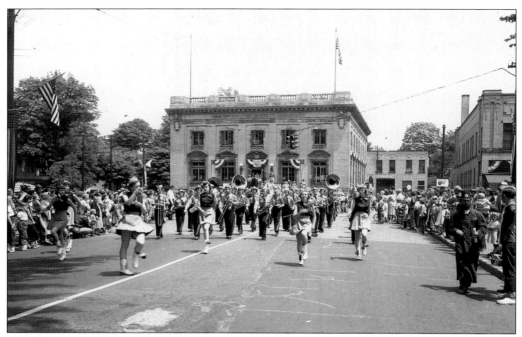

THE ASHTABULA HIGH SCHOOL BAND. Wearing their summer uniforms of gold shirts and black pants, the band passes the reviewing stand. The weather for Sesquicentennial Week was blazing hot; the newspaper reported spectators fainting from the heat while waiting for the 3:00 p.m. start of the parade.

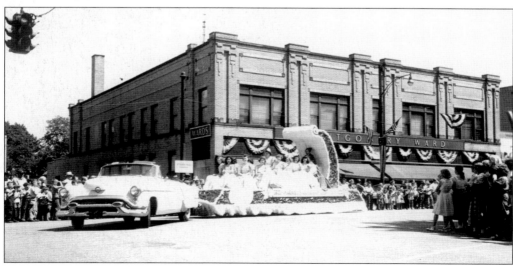

THE QUEEN'S FLOAT. Queen Jane Ferrando, Duchess Glenna Graham, and their attendants rode on this elaborate red-and-white float. As a grand prize, the queen and a companion were flown to Hollywood for two weeks.

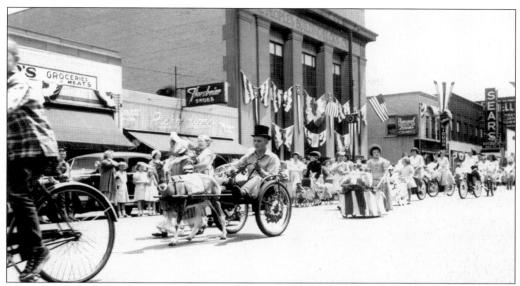

YOUTH DAY. In addition to the Kiddies Pet and Decorated Vehicle Parade at 2:00 p.m., there was a balloon release at the YMCA, Little League baseball at the field in the gulf, a Boy Scout Camporee and Girl Scout Day Camp in North Park, and special pricing on the midway rides.

READY FOR JUDGING. Prizes were awarded following the Youth Parade in vehicle, costume, and pet classifications.

PACKARD PAST AND PRESENT. Shown here is one of the brand-new prestige models (introduced in 1952) with the famed 1903 Packard that crossed the continent. Ashtabula's Packard dealer obtained this car on loan from the Henry Ford Museum with the help of James J. Nance, the president of Packard Motor Car Company. Nance grew up in Jefferson and graduated from Jefferson High School. Sims Motor Sales had a series of old Packards on display throughout the week, and the cars participated in Monday's Parade of Progress. Sims Motors was located at 4137 North Main Avenue, next door to the A&P. Ironically, before A&P moved in, the building housed a Studebaker dealer; remains of the sign are visible. The buildings, much remodeled, survive today. James Nance was seen as the savior of Packard when he took over in 1952, moving the company back into the luxury car business and accelerating research and design. But in a few short years, the independent car company was gone. In 1954, Packard merged with Studebaker, and in 1956, the company was forced to choose between keeping the Studebaker or the Packard plant. Studebaker prevailed, and the last true Packard was made in August 1956. Studebaker only lasted until 1963.

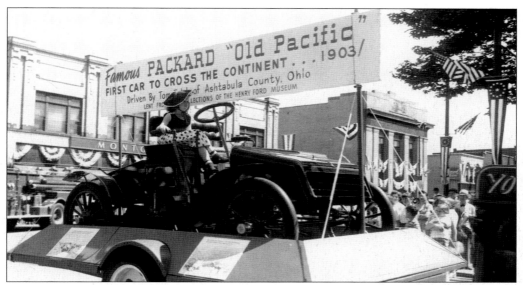

THE FIRST-PLACE WINNER IN THE ANTIQUE AUTOMOBILE CATEGORY. Fifty years after this car appeared at Ashtabula's celebration, the Packard Museum in Warren, Ohio, staged a re-creation of Old Pacific's historic journey. The driver in 1903 was E. T. "Tom" Fetch of Jefferson, Ohio; in 2003, museum board member Terry Martin and Fetch's great-nephew Tom Fetch drove a sister car, Old Pacific II, from San Francisco to New York. Included was a stop in Jefferson and a visit to the building on North Market Street that once housed E. T.'s machine shop.

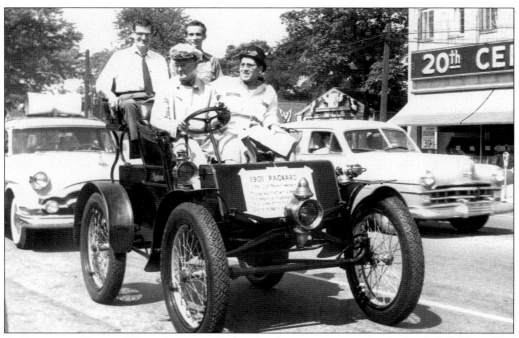

A DRIVE ON NORTH MAIN AVENUE. Riding in the rear seat are Art DeMichel (left) and Ed Andrus. The 20th Century Foods store was across the street from Sims Motor Sales, just south of the new VFW building.

READY FOR THE PAGEANT. Bula Field (later renamed Guarnieri Field) was the site of the historical pageant that played for six nights of Sesquicentennial Week. Props, many of them true antiques like this one, were often locally supplied. These costumed participants pose in front of the bandstand. By Wednesday's performance, all 2,600 seats were expected to be filled.

LAST-MINUTE DIRECTIONS. Paul and Rita Haagen, directors of the John B. Rogers Producing Company of Fostoria, arrived in Ashtabula in early May. From 1903 to 1977, the company was known for staging fundraising revues and pageants all over the country using local talent. Historical facts were provided by local historians, and the company provided a director to write the script and produce the show. A promotional director was also provided. Rehearsals began the third week in May, with final dress rehearsal the Friday before Sesquicentennial Week.

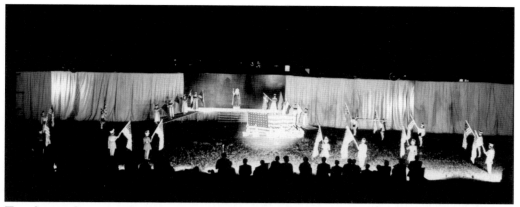

THE STAGE SET FOR *THROUGH THE YEARS*. The John B. Rogers Company also provided the stage. After each evening's performance, there was a fireworks display.

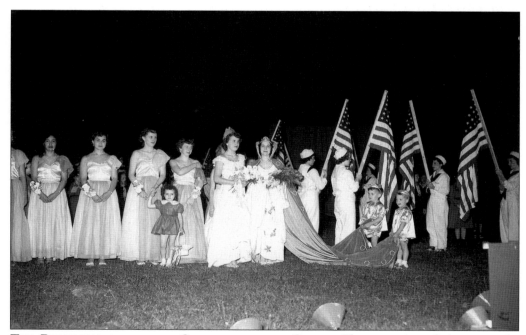

THE PRESENTATION OF THE COLORS AND THE QUEEN. The crowning of the queen by Congressman Oliver P. Bolton opened the first performance of the pageant on June 21. Pictured are, from left to right, an unidentified person (partially visible), unidentified, Dolores Kaiser, unidentified, crown bearer Kathy Volpone, Shirley Brown, and Duchess of Ashtabula County Glenna Graham. Holding Queen Jane Ferrando's train are pageboys Joseph Vacca (left) and Gary Lee Capitena. The queen was presented at each night's performance during the prologue.

BACKSTAGE PREPARATIONS. A sudden thunderstorm on Thursday flipped over the backdrops and damaged scenery, canceling the performance. The contingency plan printed in the official historical program went into effect: "In case of rain on any of the six evenings, the performance will be held Sunday evening, June 28, at which time tickets for that performance will be honored. If rain prevents two performances, these performances will be held on Sunday and Monday, and tickets will be honored on successive evenings. And if old Jupiter decides to go all out and drench Ashtabula all six nights, the six performances will be staged on successive nights beginning Sunday, with Monday's tickets being honored Sunday, Tuesday's tickets on Monday. . . . All of which will be just as confusing to the cast as it is to you—so check with your neighbor to make sure you bring the right tickets to the right performance."

YOUNG "INDIANS." These youngsters may have been part of the Y Indian Guides program.

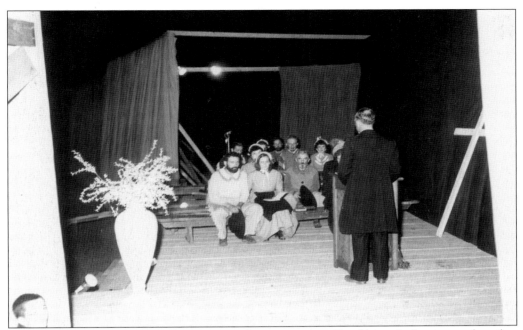

A VIEW FROM THE WINGS. The synopsis of scenes in the official historical program describes episode four, *The First Church*: "The pioneers, although a rough and ready lot, never forgot the teachings of their pious forefathers to 'Remember the Sabbath and Keep It Holy.'"

BACKSTAGE. The pageant featured a prologue presenting the colors followed by 20 episodes with titles such as *The Tavern of Peleg Sweet*, *The Harbor*, *The Lincoln Train*, *The Rebellion*, and *The Firemen's Protection Ball*. The synopsis of the finale stated, "With her hope in the cooperative action of the United Nations, her strength in supporting defense, and her faith in the youth of today who will carry on as her citizens of tomorrow—Ashtabula faces another 150 years with faith and hope and courage in things to come."

THE ASHTABULA HIGH SCHOOL BAND, 1935–1936. Director Ward W. Hamm is not in this photograph, taken in front of Ashtabula High School, but Richard Stoner is in the front row, third from the left. Stoner entered the army in 1941 and was assigned to the band. (R. S. Blakeslee photograph, courtesy Florence Stoner.)

IN THE SOUTH PACIFIC. Shortly after Stoner joined the army, his photographic skill was discovered, and he was transferred to the Signal Corps, where he did lab work and photographed the war and its aftermath. He was discharged in December 1945. Stoner stands in the bucket with his camera to document a Japanese gun. (Courtesy Florence Stoner.)

Five

RICHARD E. STONER
A HOMETOWN PHOTOGRAPHER

Richard (Dick) Stoner grew up in Ashtabula, the son of a Pennsylvania Railroad engineer. He started taking photographs when he was 12 years old. He bought his first professional camera right after he graduated from high school and took his first professional photographs in 1938. Vinton N. Herron's studio on Center Street provided the fastest film available at the time, ASA 32, and with it Stoner was able to shoot the first photographs of an Ashtabula football team on the field. For years, Herron would refer to Stoner as "that young amateur," but Dick earned his respect; when Herron retired in the early 1970s, he sold not only his studio equipment but also his glass plates and the rights to his work to Stoner.

After the war and a year at the Progressive School of Photography in New Haven, Connecticut, Stoner opened his studio on Main Avenue in 1949. As a commercial photographer, he worked for many of the major businesses and industries in Ashtabula, providing photographs for their advertising and company publications and also for insurance purposes. Stoner was the photographer on call for Markel Insurance, which had many trucking companies as clients; Markel's attorneys, C. D. and Tom Lambros, would call Stoner at home to photograph accidents, and he was often there before the safety services arrived. Carlisle's, Great Lakes Engineering, Union Carbide, Molded Fiber Glass, Pinney Dock, Linde Air, and the railroads were some of the local industries that used Stoner's services.

At a time when most families did not own a camera, Stoner also maintained a thriving portrait and wedding business at his studio and was well known as a baby photographer. In 1961, he relocated to a house on West Prospect Avenue, just around the corner from his father's house. Ike Stoner helped him build a camera room on the back, and Stoner eventually put a brick studio addition onto the front.

Dick Stoner began his career at a time when professional photography was still the dominant means of capturing a pictorial record, but technology was beginning to make amateur photography possible. The complicated, expensive cameras and the exacting developing process of black-and-white film still produced images far superior in detail and scope to any of the snapshots produced by family cameras and sent away to be developed. Stoner's black-and-white images used in this book are sharp and unfaded, the complexity of the light and shadow still intact; only the few shots taken with the new color transparency film showed significant fading after 50 years. Will the color digital photographs of the 21st century preserve as well?

Dick Stoner retired in 1997 after 58 years in the business. His photographs comprise a remarkable historic record of Ashtabula life in the 20th century. Unless otherwise stated, all images in this chapter are by Richard Stoner and are courtesy of Florence Stoner.

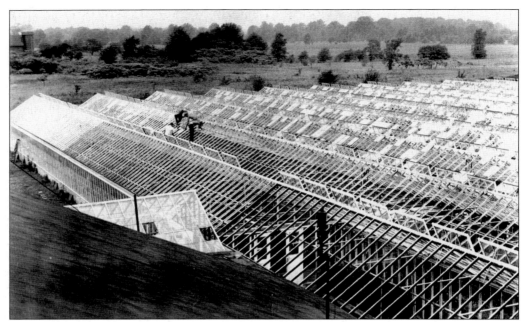

THE YODER BROTHERS GREENHOUSE, C. 1953. Ashtabula was renowned for its greenhouses in the early part of the 20th century. Produce was shipped out via railroad or processed in local canneries. A very localized hailstorm destroyed 50 percent of the glass at this North Bend Road greenhouse.

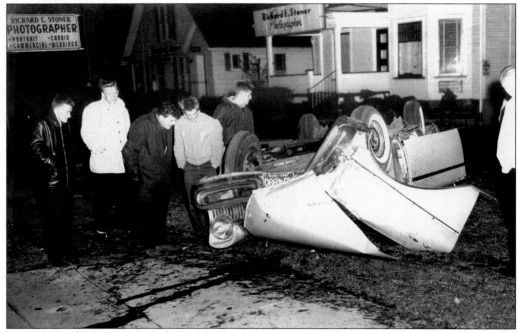

AN ACCIDENT ON WEST PROSPECT STREET, 1963. On this occasion, producing a photograph for insurance purposes did not require much travel. In the background is Stoner's studio before the front brick addition was built.

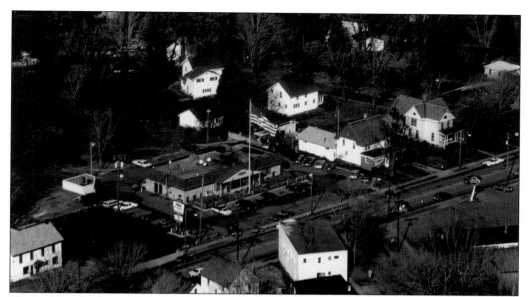

WEST PROSPECT AVENUE, C. 1974. Stoner often did flyovers for his commercial clients. He would tell his wife how he had to hang out the window of the plane to get his shots. Perkins Restaurant opened in the west end commercial area, right next door to Stoner's studio. Subsequently, much of the area across the street acquired modern commercial buildings as new strip developments along Route 20 West challenged Main Avenue's downtown business district. Twenty years later, the Ashtabula Mall area on Route 20 East is challenging this older commercial area.

THE STUDIO DARKROOM, C. 1961. Pat Kajanda waited on customers and helped process the film. This is the darkroom at the new Prospect Avenue studio.

THE AUNT MARY BIRTHDAY CLUB.
Stoner offered a plan that provided a professional portrait of a child once a year, ensuring a formal photographic record of the child's growth—and repeat business. This early-1950s birthday girl seems remarkably mature for a two-year-old.

A WEDDING PORTRAIT. Bessie Osburn Dickson, Stoner's aunt, is shown here with her five sons. Pictured from left to right are Ernie, Marvin, Lawrence, Don, and Robert on the occasion of Marvin's marriage.

FIRST COMMUNION. The present St. Joseph's Church on Lake Avenue was built in 1905–1906, replacing the 1860 frame building.

AN *ASHTABULA STAR BEACON* STAFF PICNIC, C. 1955. The Rowley family, local newspaper publishers, believed very strongly that a local newspaper helps create a sense of community. They never consolidated their Ashtabula, Geneva, Chardon, Painesville, and Madison papers, even though doing so would have made operations more efficient. But the rise of national chain stores also impacted advertising in local newspapers, and in 1984 the business was sold. Here, Millicent Rowley is at the far left in the fourth row; the third person in the same row is Wells Brockelherst, who worked in the circulation department. John Colin, vice president and general counsel, is third from the left in the back row. Ross Smith, editor, is at the far right.

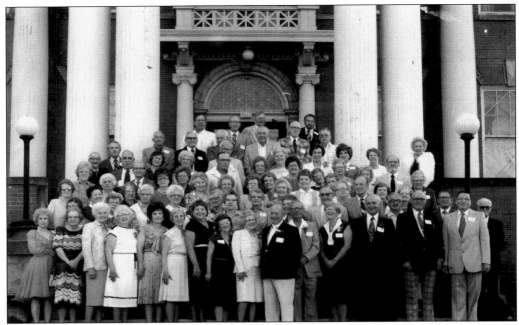

THE ASHTABULA HIGH SCHOOL CLASS OF 1933. This reunion was held at the Elks Temple on Park Avenue. The temple was built shortly after 1900 and was used until the 1960s, when Elks Lodge No. 208 built a new facility at the location of the summer Lake Shore Lodge, which had burned. The temple was torn down in 1970.

RICHARD E. STONER, 1994. Dick Stoner enjoyed two years of retirement, including a journey back to the South Pacific where he served during World War II, before he passed away in 1999. (Courtesy Florence Stoner.)

INDEX